The College History Series

MIDDLE TENNESSEE STATE UNIVERSITY

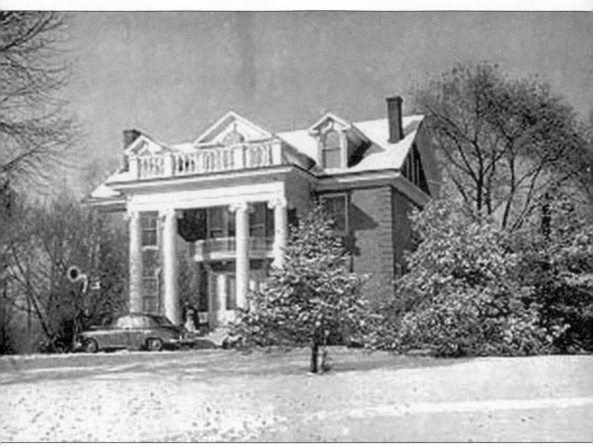

THE PRESIDENT'S RESIDENCE. "The atmosphere of the whole college is caught and mirrored in this home of cordial friendliness and beautiful dignity. It gives to the campus a charming grace and a hearty spirit of welcome" (*The Midlander*, 1933). From its site on the southwest corner of campus, the president's home lends a stately elegance as visitors enter. Nashville architect C.K. Colley designed the residence. Henry Brothers constructed it in 1910 at a cost of $10,000. It was renovated in 1956, six years after the above photograph was taken.

DEDICATION

To all who have called the campus home, however briefly:

"We do not intend this book to be more than a stimulus to your memory. There have been yesterdays; there will be tomorrows. And, no matter how much we wish it, we cannot give you back the one, or disclose to you the mysteries of the other. If, within these pages you find one thing that serves to bridge the interval of years; if we help you to remember one thing you do not wish to forget, then we will have achieved our purpose." (*Midlander*, 1935.)

The College History Series

MIDDLE TENNESSEE STATE UNIVERSITY

HOLLY BARNETT, NANCY MORGAN, AND LISA PRUITT

THE ALBERT GORE RESEARCH CENTER
MIDDLE TENNESSEE STATE UNIVERSITY

ARCADIA

Published by Arcadia Publishing,
an imprint of Tempus Publishing, Inc.
2 Cumberland Street
Charleston, SC 29401

Printed in Great Britain.

Library of Congress Catalog Card Number: 2001089850

For all general information contact Arcadia Publishing at:
Telephone 843-853-2070
Fax 843-853-0044
E-Mail sales@arcadiapublishing.com

For customer service and orders:
Toll-Free 1-888-313-2665

Visit us on the internet at http://www.arcadiapublishing.com

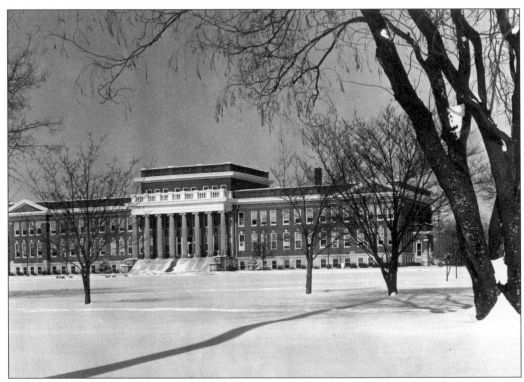

KIRKSEY OLD MAIN. Shown *c.* 1955, it is one of the four original 1910–1911 buildings on campus. For the first three decades, the Administration Building housed all of the college's administrative and academic functions. Now used for classes and faculty offices, the KOM remains the traditional symbol of the university's built environment.

CONTENTS

ACKNOWLEDGMENTS

Several sources were consulted in compiling the introduction and captions for this publication, and much of the information is based on Homer Pittard's *The First Fifty Years: Middle Tennessee State College, 1911–1961* (Murfreesboro, TN: MTSC, 1961); Joe E. Nunley's *The Raider Forties* (New York: Vantage Press, 1977); and Bobby Newby's *They Bled Raider Blue* (np: np, 1996). We relied heavily on college catalogs, yearbooks, and student newspapers supplemented by materials in the Gore Research Center from the following collections: MTSU Alumni, MTSU News and Public Affairs, MTSU Memorabilia, Oral History Collection, Baskin, Boutwell, Community, Hoover, Jones, Licker, Nunley, Pittard, Schardt, Sloan, Q.M. Smith, and Wright. The photographs are from those collections as well as from current and previous MTSU faculty and alumni who generously loaned them for our use. Departments of Aerospace, Agriculture, Biology, HPERS, and Photographic Services, Center for Popular Music, Joe Smith, Bud Morris, Phillips Bookstore, and Frank Victory generously donated or loaned photographs. A special thanks to David Cerchiaro of MTSU's Radio-TV/Photography Department for his assistance in developing old negatives.

When discrepancies occurred, we used the source closest to the event in time and relationship. Graduate assistants Holly Barnett and Nancy Adgent Morgan researched, prepared, and selected the content. Student worker Juanika Randolph scanned and catalogued the vast majority of our photographs. Dr. Lisa Pruitt directed the project and edited the final manuscript with the assistance of Betty Rowland. We also wish to thank the editorial and production staff of Arcadia Publishing whose expertise polished the final result.

THE NORMAL FARM. This campus view to the north shows the site as it probably appeared when first purchased by Middle Tennessee Normal. Symbolic of the university's landscape alteration during its first three decades, the field between classroom buildings and the Barn evolved from a vegetable garden and cow pasture to a baseball diamond.

INTRODUCTION

Middle Tennessee State University has experienced four major phases in its 90-year history. In 1911, the Tennessee General Assembly created the Middle Tennessee Normal School (MTN) to serve as one of three two-year teacher-training facilities in the state. The second major phase in the school's history began in 1925, when it became a four-year institution with authority to award bachelor of science degrees. To reflect that broader mission, the General Assembly changed the name to Middle Tennessee State Teachers College. In 1943, the college entered the third major phase of its history. Changing the institution's name to Middle Tennessee State College, the General Assembly broadened the school's mission to include a general liberal arts education in addition to teacher training. Finally, its course offerings having expanded to include a number of liberal arts and professional degree programs, the college acquired university status in 1965 and changed its name to Middle Tennessee State University.

This pictorial history offers a chapter documenting each of the four major phases in MTSU's history. Each chapter includes a variety of pictures depicting landscapes and buildings, academic pursuits, and student life. Browsing through this volume, the reader can trace the transformation of the original site (a 100-acre farm) first into a sparsely settled campus "village" and then gradually into the current bustling, urban campus. During the "Normal's" first decade, students arriving by train were advised to meet the "Normal wagons." Local students could park their horses and buggies in a shelter near the present stadium. Gradually, as cars became increasingly important in American culture, the student body evolved into one comprised primarily of commuters. Crowded parking lots rim the campus landscape today. MTSU also experienced dramatic growth in its physical facilities during its first 90 years. The Normal opened in 1911 with four buildings: an administration building (now Kirksey Old Main), a women's dormitory (Rutledge Hall), a dining facility (now the Alumni Center), and the president's home. The campus currently has over 100 buildings occupying more than 500 acres. Despite such dramatic changes, however, some things have stayed the same. In the school's early years, inadequate drainage created "Lake Unnecessary" near the president's home, sometimes preventing students from entering the campus. Current students, who often have to wade through large, ankle-deep ponds on campus following heavy rains, can sympathize with their counterparts of 90 years ago!

MTSU has also experienced significant changes in its faculty and academic programs. The Normal School opened with a faculty of 19, who focused on training students in a two-year program to become schoolteachers. Today, the university has a faculty in excess of 700, who teach courses in programs ranging from aerospace technology to the recording industry to the traditional liberal arts curriculum. The bachelor of arts degree was added in 1936. In 1939, business administration became an independent department, signifying the rising importance of the corporate world. The graduate school opened in 1951. In 1962, the administration reorganized the academic programs into "schools," which became "colleges" with the advent of university status. Beginning in 1970, some of those colleges added Doctor of Arts degree programs specifically designed to train college-level teachers to serve in institutions of higher education that focused on teaching rather than research. Education

and agriculture, the two early cornerstones of the "Normal," continue to play a significant role in the academic mission of the university. From its inception, the university has operated a public school that provides training opportunities for teacher education majors. The Homer Pittard Campus School continues to provide a unique educational setting for kindergarten through eighth-grade students. Similarly, the "Normal" offered agricultural training to students through its model demonstration farm. Students grew vegetables and provided dairy products for the dining hall in those early years. The university's agricultural facilities have expanded greatly over the years and its programs now train students for careers in agribusiness and animal science.

As the number of students grew from 125 in 1911 to almost 20,000 by the fall of 2000, student activities were expanded and diversified accordingly. Student activities during the "Normal" years were limited to four literary societies, a couple of athletic clubs, and a few other organizations such as the YMCA, YWCA, the Country Life Club, and the Glee Club. A monthly student newspaper, *The Signal*, covered events during most of the period from 1913 to 1925, when it was renamed *Sidelines*. A yearbook called *The Normalite* was published annually from 1912 to 1925; it became *The Midlander* beginning with the 1926 edition. A fledgling football team played a few games in 1912; baseball and basketball joined football within a few years to provide athletic activities for men. While most men's athletic teams played on the intercollegiate circuit, women's sports were primarily intramural at first. Women's sports offerings, however, were fairly extensive for the 1910s and 1920s and included basketball, softball, tennis, track, and volleyball. In 1939, students established a governance system called the Associated Student Body (ASB), later changing the name to Student Government Association. Greek organizations appeared on campus beginning in the 1960s. By 2001, students could choose from over 200 registered student organizations, including honor societies, professional organizations, sports clubs and teams (both intramural and intercollegiate), political groups, religious organizations, and social service clubs.

Many of the institutional changes detailed here and in the pages to follow came in response to external influences. From its inception as the Middle Tennessee Normal School in 1911 up until the present day, MTSU has never stood apart and isolated itself from developments in the broader American society. World War I, the Great Depression, Roosevelt's New Deal, World War II, the GI Bill, integration, the women's rights movement, the disability rights movement, economic and population growth in the Sunbelt in general and in Rutherford County in particular—these are just a few of the myriad influences that have helped shape MTSU into the diverse, modern institution that it is today. But those influences were carried by thousands of individuals—students, faculty, administrators, and staff. The staff of the Albert Gore Research Center offers this book as an expression of gratitude and as a tribute to those who went before us and whose successive efforts over the decades built Middle Tennessee State University.

One
MIDDLE TENNESSEE NORMAL SCHOOL
1911–1924

MTN's Logo. This logo appeared on early catalogs and other school publications.

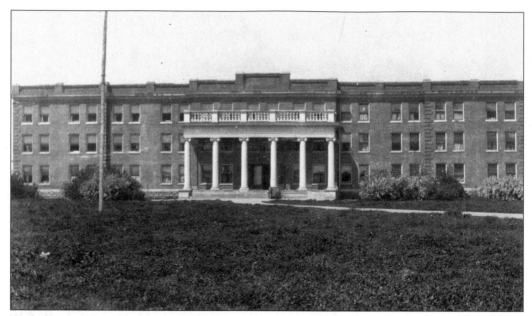

RUTLEDGE HALL, BUILT 1910. The building was later named to honor dormitory matron Elma Rutledge. The 1933 *Midlander* commented "'It takes a heap o'living in a house to make it home' seems to fit 'The Old Girls' Dormitory,' for it has taken the personality of every girl who has ever lived there and with the aid of years subtly turned all of the laughter and fun into the beautiful, quiet dignity that seems to radiate from it."

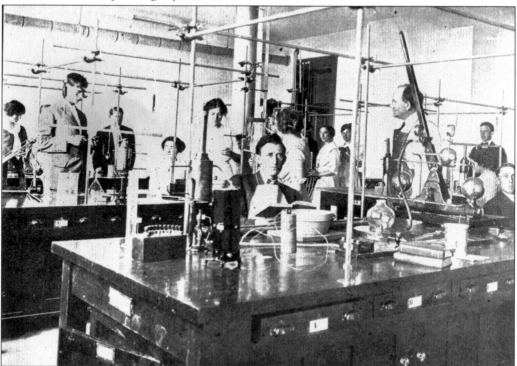

PHYSICAL SCIENCE LABORATORY. During MTN days, this laboratory was located in the first floor west wing of the Administration Building.

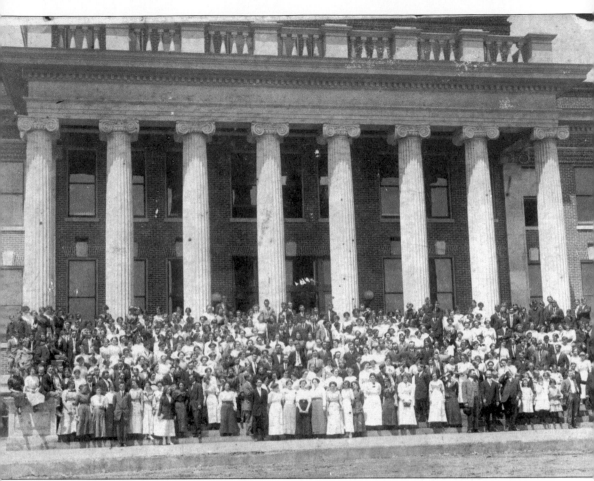

FIRST STUDENT BODY AND FACULTY IN FRONT OF THE ADMINISTRATION BUILDING, 1911–1912. For several decades, the "KOM" was the focal point of campus life. Former student Zadie Key recalled, "Many romances started on the steps of Kirksey Old Main."

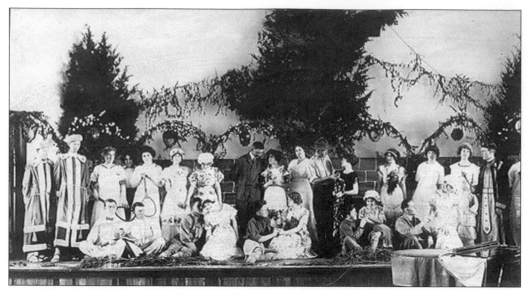

COMMENCEMENT OPERETTA PERFORMED BY ENTRE NOUS GLEE CLUB, 1913. "Bread and water for a week, that will be our fate,/Or perchance the dungeon cell, not yet out of date./Nothing venture, nothing have so we hope the best./Enter into plot and plan, with a merry jest."

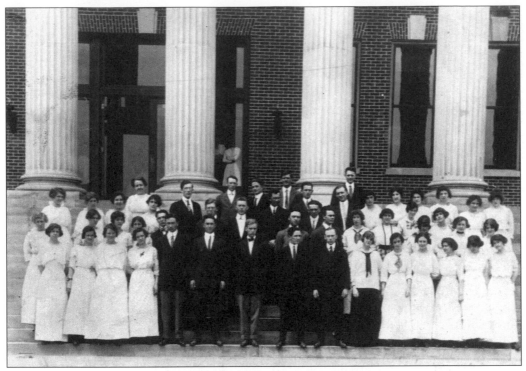

GROUP OF STUDENTS. This assembly is possibly the 1913 graduating class

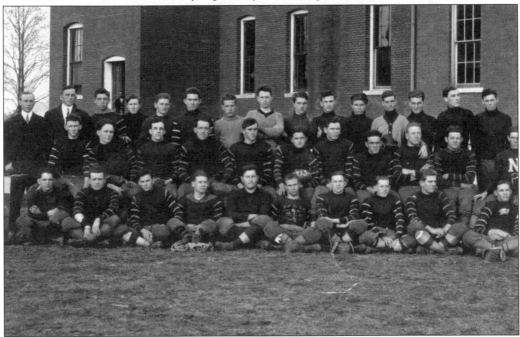

MEN'S ATHLETIC ASSOCIATION, 1913–1914. The men's athletic association included football, basketball, and baseball players. Faculty members Jeannette King and Tommie Reynolds and student Quintin Miller Smith selected blue and white as the school colors in 1912. Smith later served as MTSC's president (1938–1958).

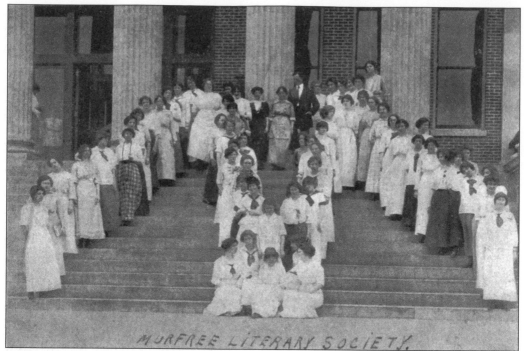

MURFREE LITERARY SOCIETY, 1914. Named in honor of Murfreesboro writer Mary Noailles Murfree, the club was the sister organization of the Grady Literary Society (pictured below). "So often the social side of life is neglected, but not so with the M.T.N. pupils. Four literary societies are found here. Two for the girls and two for the boys. The old members are urging the new pupils, who have or have not been injured by the lack of such, to feel perfectly free and easy to become a member of the society of their choice. The contests are grand! The programs are splendid and the spirit is enchanting. These societies will uproot buried talents and train us for service." (*Normalite*, October 1922.)

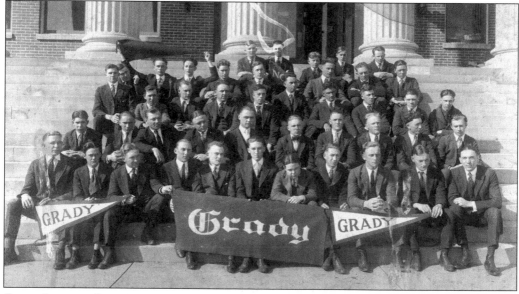

GRADY LITERARY SOCIETY.

14

AUTHOR OF FIRST ALMA MATER. According to Homer Pittard, William J. McConnell, a student at MTN, wrote the first alma mater lyrics in 1914 with encouragement from Miss E. Mai Saunders, a music teacher.

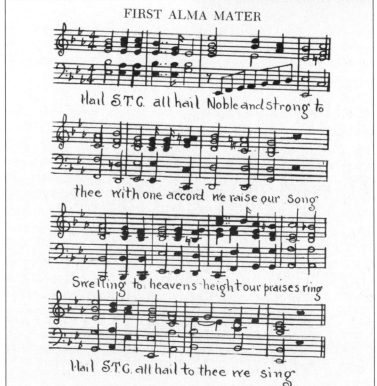

FIRST ALMA MATER

Hail S.T.C. all hail Noble and strong to thee with one accord we raise our song Swelling to heavens height our praises ring Hail S.T.C. all hail to thee we sing

FIRST ALMA MATER. According to *The First Fifty Years*, the songwriter died performing Red Cross duty in World War I—several years before the school's name changed from MTN to STC. The letters "STC" were substituted for "MTN" after the name change.

15

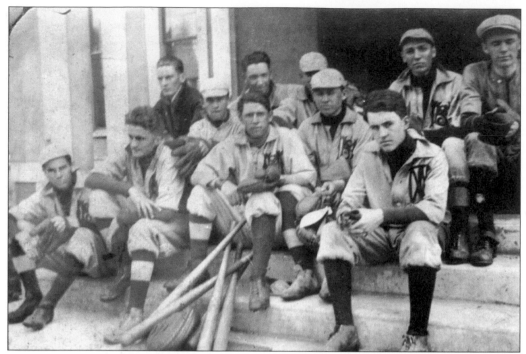

"Baseball Stars," 1913–1914. The baseball team, begun in 1912, was the first organized team of any kind at MTN. The first baseball coach was a history professor named Max Souby (*First Fifty Years*, 249).

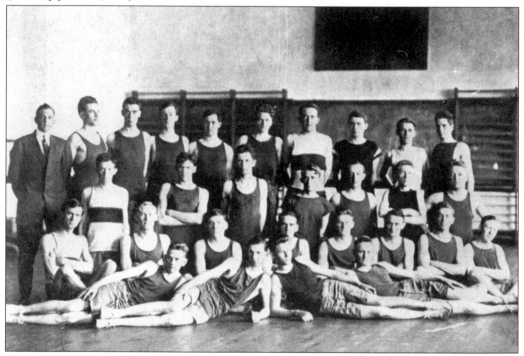

Track Team, 1914. Track was not a very prominent sport at MTN. It is uncertain whether this team ever represented the school at a formal, intercollegiate meet.

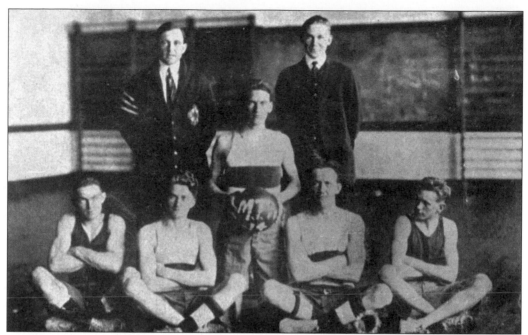

BASKETBALL TEAM, 1914. Their arena was the "Old Gym," which had a playing court measuring 50 by 70 feet and spectator seating for 800. Amenities included an equipment room, separate rooms for the women's director and the men's director, dressing rooms, showers, and lockers.

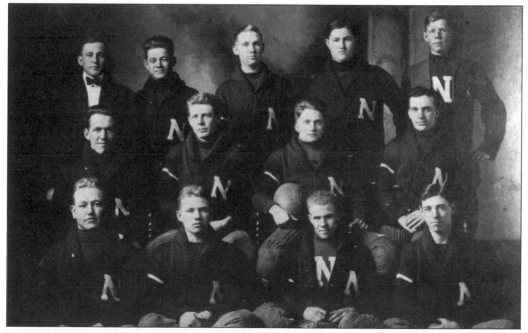

FOOTBALL TEAM, 1914. According to one source, the first MTN football team was called the "Pedagogues" (*They Bled Raider Blue*, 12). Coach Alf Miles attended both the Normal School of Physical Training in Battle Creek, Michigan, and the Harvard Summer School of Physical Training (*First Fifty Years*, 257).

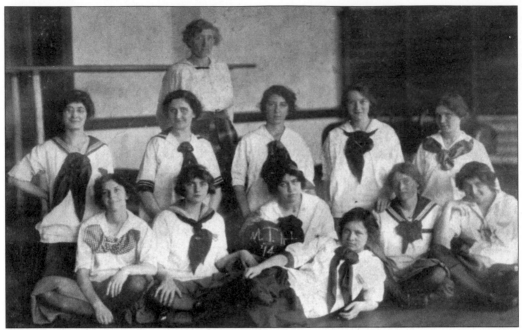

WOMEN'S BASKETBALL TEAM, 1914. Basketball was a popular sport for both women and men at MTN. In 1913 each team challenged faculty members to a game. The male faculty declined the challenge; the women accepted provided that no men be allowed to attend (*First Fifty Years*, 77).

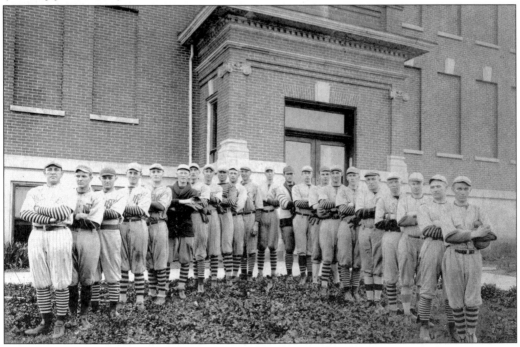

BASEBALL TEAM, 1915. The athletic policy of the Normal School was described in the 1916–1917 catalogue as being "favourable to the development of a sane and wholesome athletic spirit among the students."

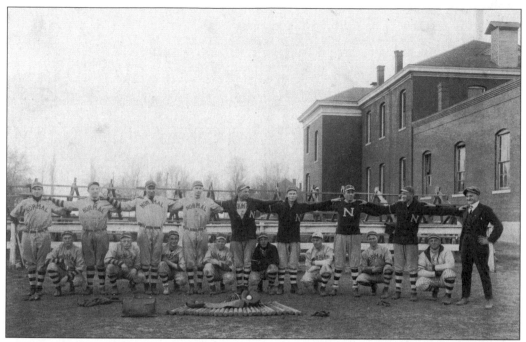

BASEBALL TEAM, 1915. For this photograph the coaches and managers joined the players, who proudly displayed their equipment.

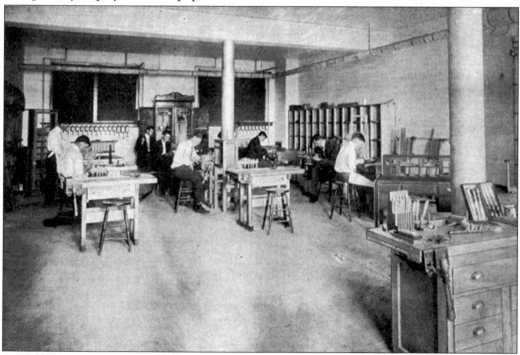

MANUAL TRAINING WORKSHOP IN THE BASEMENT OF THE ADMINISTRATION BUILDING. Students in the Manual Arts Department workshop crafted furniture as well as other items for agricultural applications. In addition, they learned forging, concrete work, and harness mending.

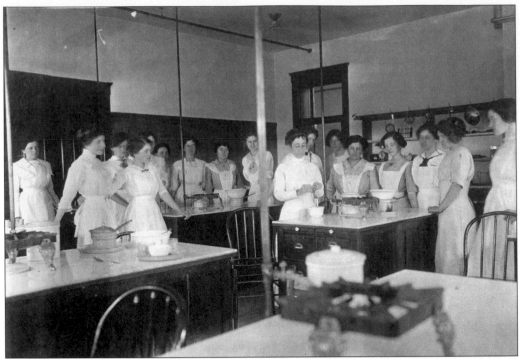

DOMESTIC SCIENCE LABORATORY, 1914. "The Home Economics Department is presenting a most pleasing appearance in her new adornments. The beautiful new cabinet consisting of forty individual lockers and ample space for hanging garments, while in construction and when finished, adds greatly to the convenience of the Domestic Art classes; and the splendid new sewing machines make the work much lighter. This house is to be occupied by a different group of girls each quarter. The group will live as a family, practicing the arts of household management in the most practical and scientific way." (Mrs. T.E. Clark, president of the Home Economics Club quoted in *The Normalite*, October 1922).

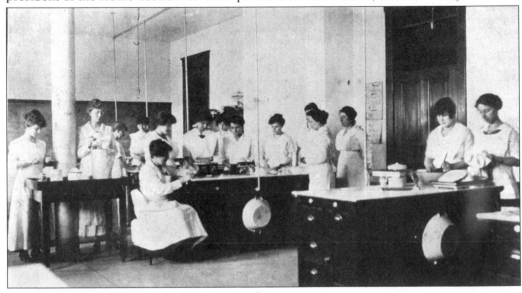

CORNER DOMESTIC SCIENCE LABORATORY, 1916–1917.

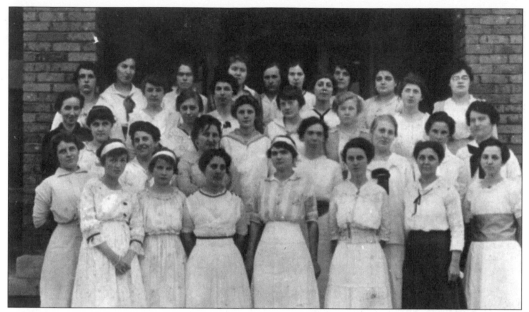

UNIDENTIFIED GROUP OF STUDENTS, 1915. Throughout the Normal School's existence, female students outnumbered male students every year. The year this picture was taken, female students numbered 395 and male 199.

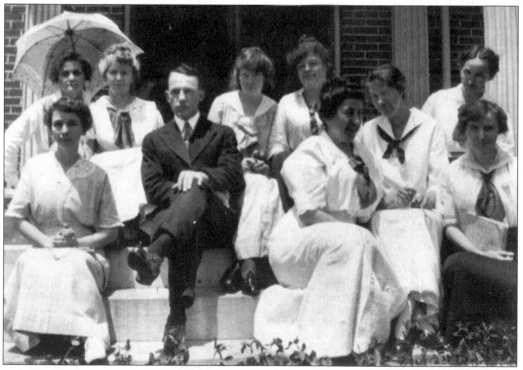

TEACHER CERTIFICATE RENEWERS, 1915. Non-degreed teachers with one year of experience who had completed one normal school term received teaching certificates that allowed them to teach for an additional year, contingent upon their attending subsequent terms—usually summer sessions.

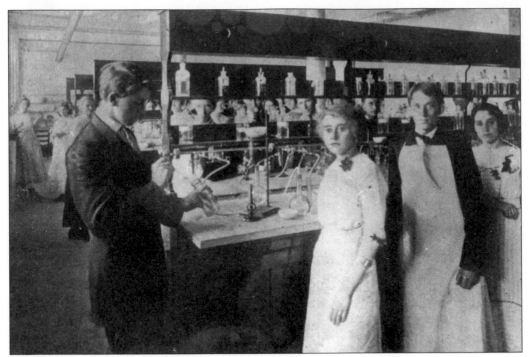

CHEMISTRY STUDENTS, 1916–1917. The chemistry laboratory shared the first floor of the west wing in the Administration Building with the physical science laboratory.

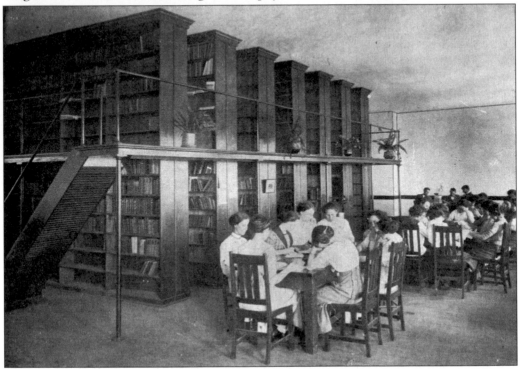

THE ORIGINAL LIBRARY, 1916–1917. Students study in the original library located in the Administration Building.

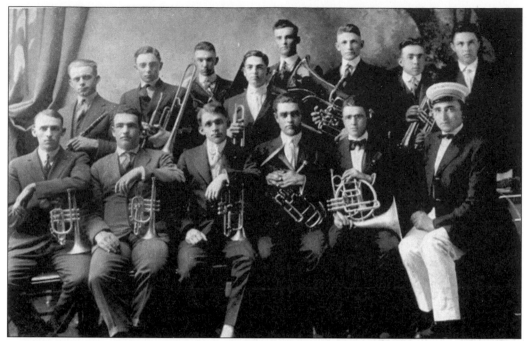

MIDDLE TENNESSEE NORMAL BAND, 1916–1917. Beecher Golden directed the Normal Band, one of the few musical groups not led by Miss E. Mai Saunders. Homer Pittard recalled, "Its most significant performance during its first year of existence was leading the student body in its uptown 'wild cat' parade, celebrating Woodrow Wilson's election."

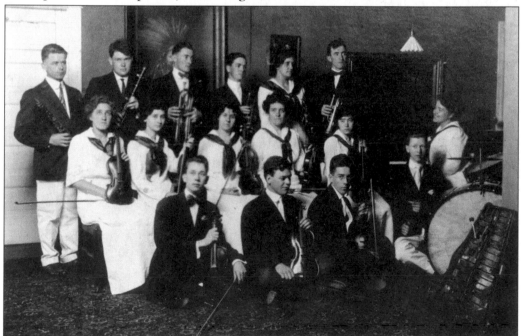

MIDDLE TENNESSEE NORMAL ORCHESTRA, 1916–1917. This group often entertained faculty and students on Friday nights. The orchestra was founded by music teacher E. mai Saunders in 1913.

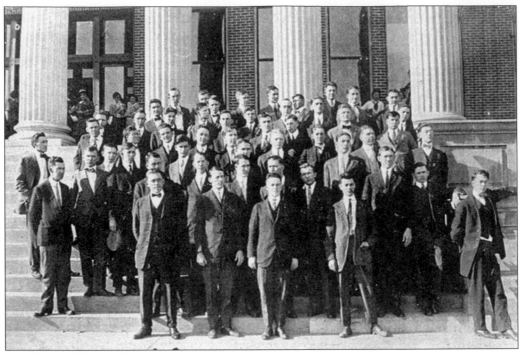

YMCA, 1917. Among the earliest campus organizations, the Y played a significant role in student life. Local preachers conducted Sunday night services in the dormitory lobbies. With the strict behavior rules of the time, the Y provided welcome social life.

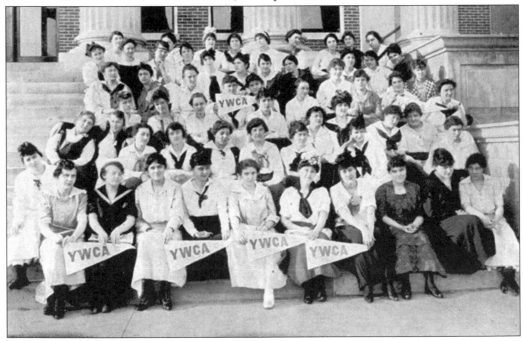

YWCA, 1916–1917. In 1917, the group contributed five new volumes, *The Bible Story*, to the library. At one meeting, Miss Tingling of the Young People's Branch of the Women's Christian Temperance Union spoke.

COUNTRY LIFE CLUB, 1916–1917. The club completed rural surveys and studied and visited rural communities. Activities included attending a county-wide teachers' meeting in Smyrna and holding an all-day picnic at Caney Fork Falls.

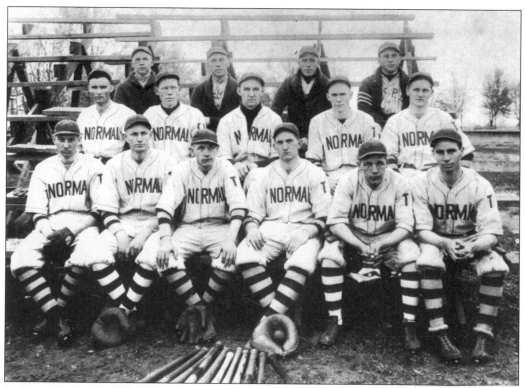

BASEBALL TEAM, 1916–1917. The May 1917 issue of the *Signal* stated that there "has not been much doing here this spring in an athletic way. This is due to the fact that the athletes have hied it back to the farm to be a 'hero in the furrows.'" The MTN baseball team played only three games in the 1917 season.

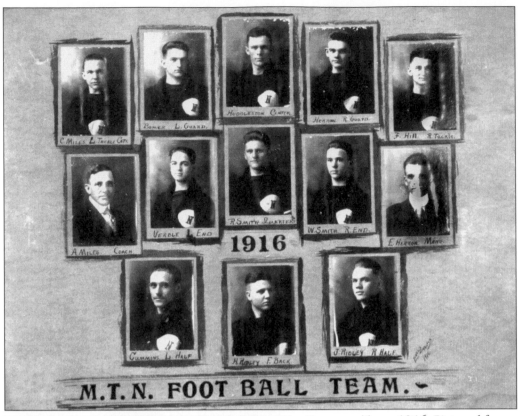

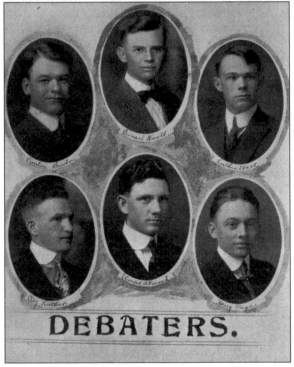

FOOTBALL TEAM, 1916. Pictured from left to right are (top row)_C. Miles, tackle; Bomer, guard; Huddleston, center; Herron, guard; F. Hill, tackle; (middle row) A. Miles, coach; Verble, end; R. Smith, quarterback; W. Smith, end; E. Herron, manager; (bottom row) Cummins, halfback; H. Ripley, fullback; J. Ridley, halfback.

DEBATE TEAM, 1917. Pictured from left to right are (top row) Winston Burton, Bernard Knott, and Luther Wall; (bottom row) Clay Luther, Wendell Atwood, and Harry Page. In the spring of 1917, the team debated the question "Resolved, that in the present War, the United States should raise an Army by the Volunteer System rather than by Conscription."

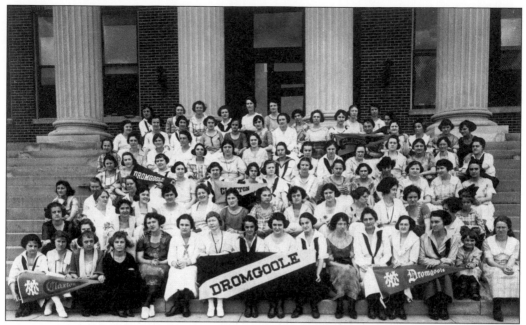

DROMGOOLE LITERARY SOCIETY. Dromgoole Literary Society was the sister organization of the Claxton Literary Society. According to the 1917 *Signal*, on April 27, Miss Will Allen Dromgoole, a local author and the group's namesake, was the honoree at an outing on the Normal Farm. "The time was spent pleasantly in playing games, in singing, and in storytelling. Just before returning to the dormitory a delightful picnic supper was served." Later the Claxtons and Dromgooles gave a combined program, Miss Dromgoole spoke on "Service," and the group enjoyed a social hour.

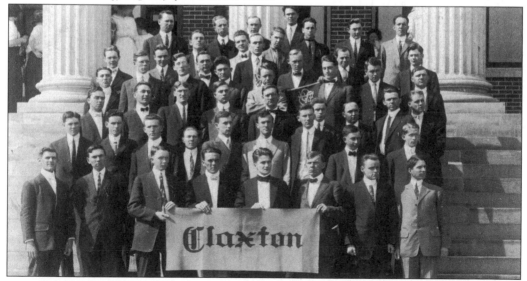

CLAXTON LITERARY SOCIETY. "The Dromgooles and Claxtons gave their usual joint program at the first meeting of the Fall Term. Addresses of welcome were delivered by the presidents of both Societies. The program consisted of readings, dialogues, musical numbers, and contests followed by refreshments and social hour. A large crowd was present and all sitting and standing room was taken." (*The Normalite*, October 1922.)

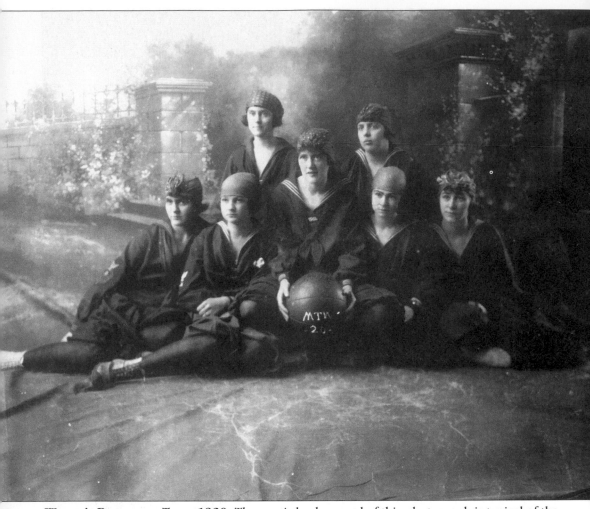

WOMEN'S BASKETBALL TEAM, 1920. The exotic background of this photograph is typical of the "harem" style popular for college athletic team portraits of the 1910s and 1920s.

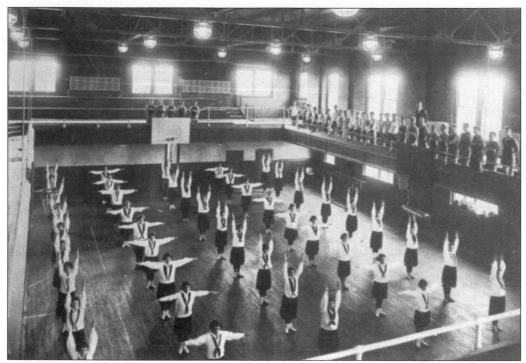

WOMEN'S PHYSICAL EDUCATION CLASS, c. 1920. The "Old Gym" was located in what is today the Midgett Business Building. MTN followed national trends in emphasizing the importance of physical education for women and men alike.

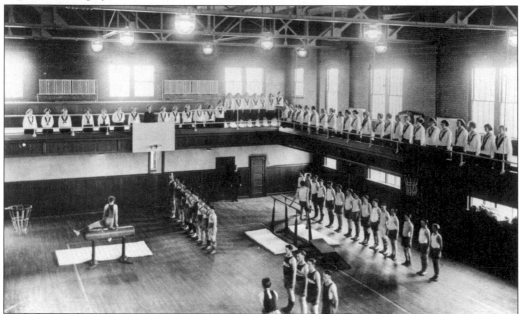

MEN'S PHYSICAL EDUCATION CLASS, c. 1920. Physical training included "Swedish Education Gymnastics, volleyball, basketball, German ball, playground ball, baseball, football, soccer, field hockey, lawn tennis, track athletics, gymnastic games, calisthenics, marching tactics, folk dances." (*MTN Catalog*, 1916–1917.)

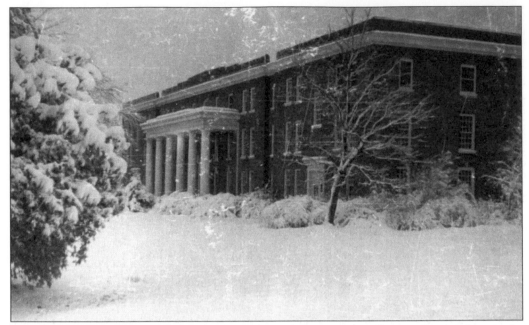

JONES HALL. Named for the first Middle Tennessee Normal president, Robert L. Jones, the first men's dormitory was constructed in 1921. Prior to that time, male students either commuted via horse and buggy or lived in one of the nearby homes, principally the Kittrell Home, a two-story frame house on East Main.

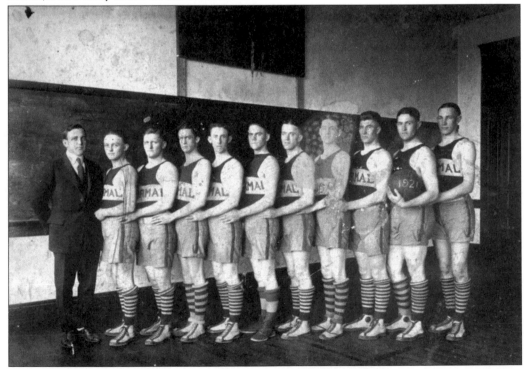

MEN'S BASKETBALL TEAM, 1921. Pictured from left to right are Alf Miles (coach), Laws, Smith, Shearron, King, Bostick, Clardy, Batey, Overall, Carter, and Larkin.

MEN'S GLEE CLUB. The October 1922 *Normalite* reported that, although "the Men's Glee Club had met several times in informal rehearsal, the organization of the club was perfected on Thursday evening, October 12." The Women's Glee Club had organized on October 2.

FOOTBALL TEAM, *C.* 1922. "Prospects for a football team of first rank are unusually good at M.T.N. this fall. Coach Miles has corralled a squad of big, stalwart, husky fellows, with proper training in the fundamentals of the game, should develop into a strong and powerful eleven." (*The Normalite*, October 1922.)

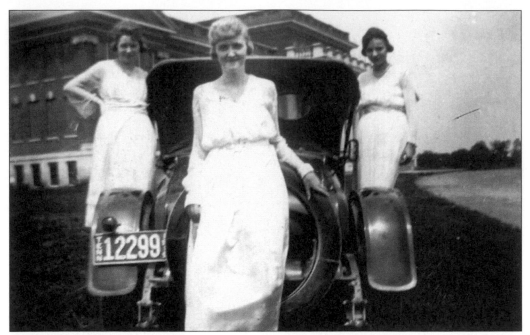

CAMPUS BEAUTIES, 1920. These fashionable young women pose in front of the Administration Building.

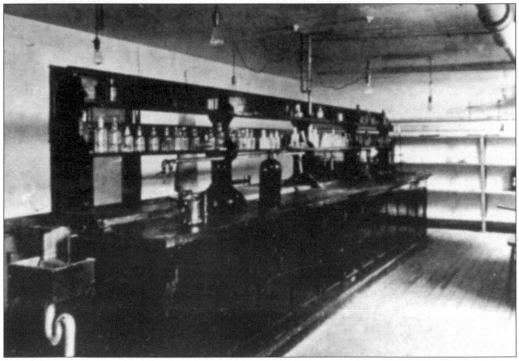

THE SCIENCE LABORATORY. "The Science department offers better opportunity for laboratory work this year than ever before in its history," the *Normalite* reported in October 1922. Over the summer, the school had acquired "a large amount of new chemical supplies and apparatus."

WOMEN'S DORM ROOM. "Each bedroom has a lavatory with hot and cold water. Bathroom provided for each eight students. Every room in the building is an outside room, all sanitary arrangements are modern. Each room is furnished with shades, a rug, table, dresser, chairs, iron bedstead and mattress and springs." (*Daily News Journal,* MTSU Diamond Anniversary edition, September 7, 1986.)

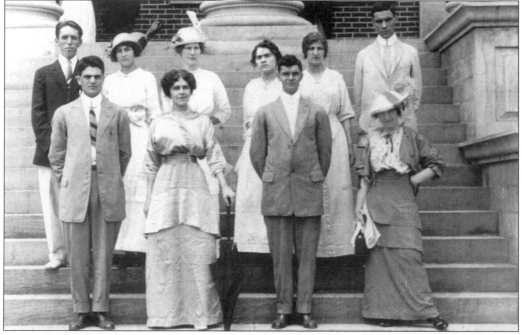

ON THE STEPS OF THE ADMINISTRATION BUILDING, *c.* **1925**. This group is possibly made up of faculty members.

READY TO GO ON AN OUTING. This group, possibly members of the Murfree or Dromgoole Literary Society, prepares to go on a trip.

MIDDLE TENNESSEE NORMAL'S DAIRY HERD. Fifty cows provided a source of income for the college and offered employment for some students. Other agriculture class projects included raising chickens in the basement of the Administration Building. The October 1922 *Normalite* announced, "Another honor has come to our worthy and much-honored M.T.N. This time it is through the poultry department. Mr. Gracey carried off prizes in the State Fair and in the local show."

ON THE STEPS OF THE DINING HALL. The 1933 *Midlander* described the building as "the merriest spot on the campus from seven in the morning until six in the evening—and why shouldn't it be? The hall is pretty—the clatter of dishes comfortable, and the constant hum of voices and laughter brings out the gaiety in all."

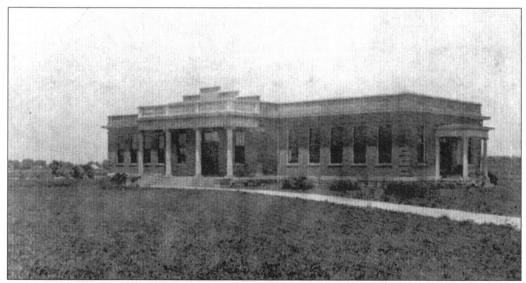

THE DINING HALL (NOW THE ALUMNI CENTER). One of the original campus buildings, the cafeteria served townspeople Sunday lunch and Thanksgiving dinner during World War II. Former education director Joe Nunley recalled, "They liked the general atmosphere and the food was good. Big wheels came. We were proud of the cafeteria and were proud of the school." (*Daily News Journal,* MTSU Diamond Anniversary edition, 7 September 1986.)

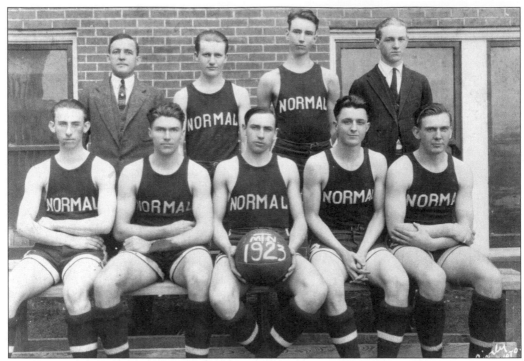

MEN'S BASKETBALL TEAM, 1923 (ABOVE) AND 1924 (BELOW). "One of the greatest assets to any institution is good athletics. It's the biggest drawing card and advertisement that a school can have. Clean, wholesome, and uplifting athletics, comprising and embracing that fundamental spirit of cooperation between faculty, student body, and team, does more to attract the eye of the public than anything else." (*The Normalite*, November 1922, page 61.)

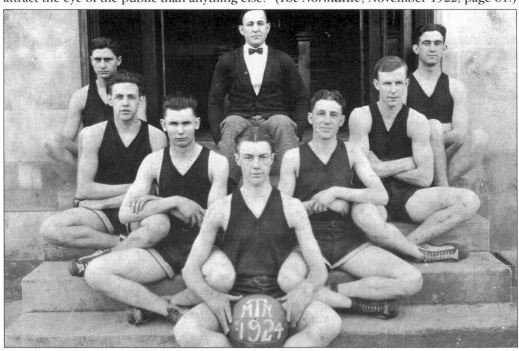

TENNIS PLAYERS, *c.* 1920. "Flappers are not just pleasure pursuers either. They study and think how to come up against the world and its many problems. The girls of today know more than their mothers did, but they have to and they are braver. The line of poetry that runs: 'The modern maid is unafraid,' about fits the flapper." (*The Normalite*, November 1922, pages 19–20.)

CAMPUS SCHOOL. Pictured here in front of the Administration Building, *c.* 1925, are the Campus School's first-grade class and teacher. The Campus School provided hands-on training for aspiring educators.

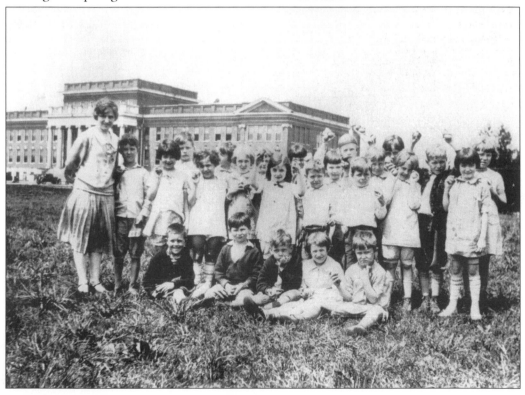

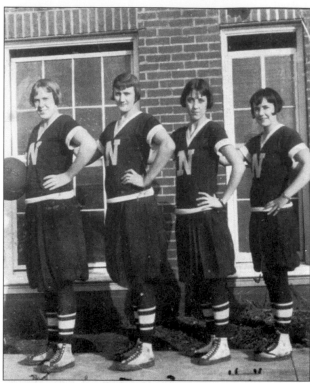

WOMEN'S BASKETBALL TEAM, *C*. 1924. "From about 1923 to 1927 the girls basketball team really gave the fans a thrill. They won practically all games played and were Southern champions for two years." (Frank Bass, "Athletics as Seen by an Alumnus," Murfreesboro *Daily New Journal* Supplement, June 5, 1936.)

WOMEN'S BASKETBALL TEAM, 1925. This team was the last one known as "The Normal."

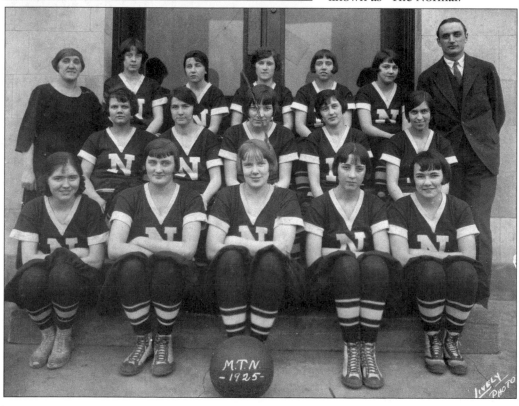

Two

STATE TEACHERS COLLEGE

1925–1943

WORLD WAR II SUPPORT TRAINING. Although World War II arrived near the end of the STC days, it dominated the period even more than the Depression years did. Engineering drawing was one of the new classes added to support the country's wartime effort. Enrollment reached its lowest level since 1911. Women students comprised a significant majority from 1942 until 1946, when veterans returning to school under the GI Bill caused a campus population explosion.

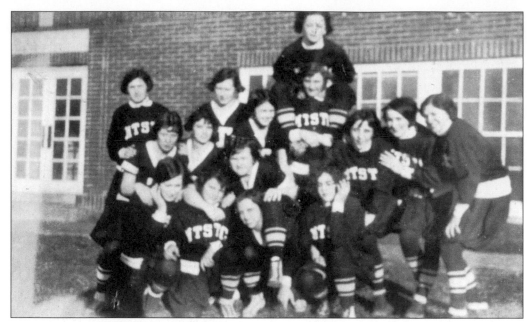

WOMEN'S BASKETBALL TEAM, *C.* 1928.

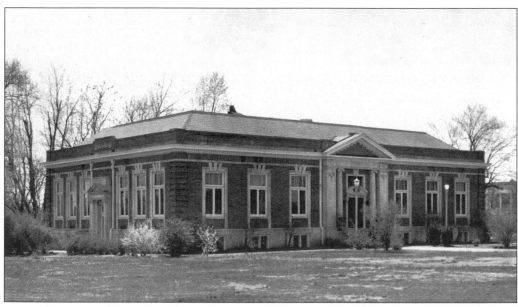

THE LIBRARY/MURFREE HALL. "This is the busiest place on the campus. Since its foundation in 1927, there have been very few days when it was not in use from eight o'clock in the morning until five in the afternoon. It seems that books are truly the pleasantest things in the world." (*Midlander*, 1933.) Designed by C.K. Colley, the building stood near the present site of Peck Hall. Named for Mrs. Bettie Murfree, the librarian from 1911 until 1945, the building later housed the English Department for ten years until it was demolished in 1968.

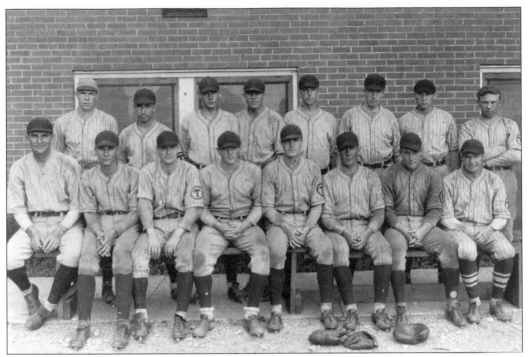

BASEBALL TEAM, 1928. Pictured from left to right are (front row) Frank Faulkinberry, coach; Roy Bass, outfield; Ralph Askins, shortstop; Charley Yeargin, outfield and infield; Tom Thompson, outfield and infield; John Bass, first base; Jesse Gregory, catcher; Noah Turpin, outfield and infield; (back row) Seth Springer, outfield; Howard Coleman, third base; Ramon McRory, catcher; Kurfees Pullins, outfield; Hilliard Phillips, pitcher; Hubert Swann, pitcher; Pete Howser, pitcher; and Price Womack, outfield.

BASEBALL TEAM, *c.* 1930. These baseball team members pose on the steps of the Administration Building.

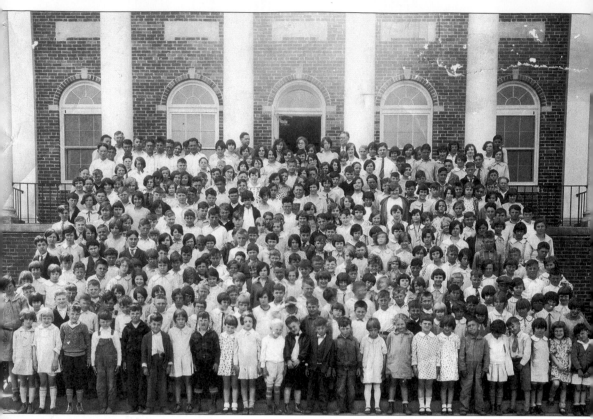

CAMPUS TRAINING SCHOOL GRADES ONE THROUGH EIGHT, 1929. Director J.C. Waller, along with nine "Critic Teachers," supervised the student teachers. When Middle Tennessee Normal became State Teachers College in 1925, the elementary school was housed in the Administration Building. In 1927, it moved to the East End Grammar School building on East Main Street prior to the completion of the building shown above. The present building sits on land donated by the City of Murfreesboro near the Bell Street parking lot.

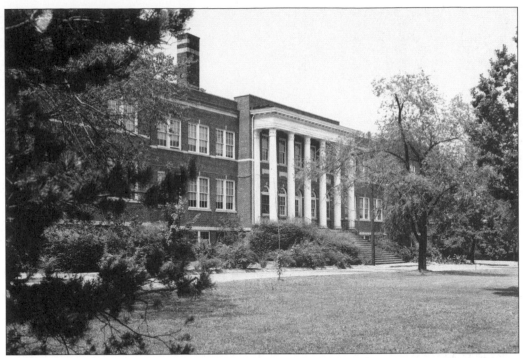

CAMPUS SCHOOL. Now called Pittard Campus School in honor of Homer Pittard, a longtime MTSU education professor, the "practice" school was known variously as the Model School, Model Practice School, the Demonstration School, and the Training School.

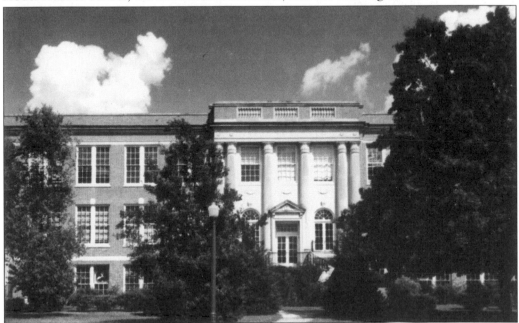

SCIENCE HALL. Built in 1931, Science Hall, now known as Wiser Patten Science Building, had a large second-floor reception hall with chandeliers and marble columns. The 1933 *Midlander* described it as standing "aloof, baring her roof to the sun, and leading the steps of inquisitive ones into the way of higher service to mankind."

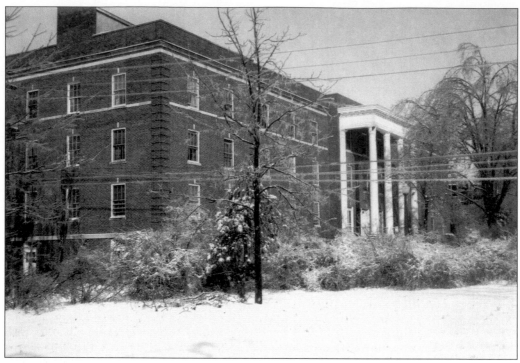

LYON HALL. The second women's dormitory was built in 1933 to house 120 students.

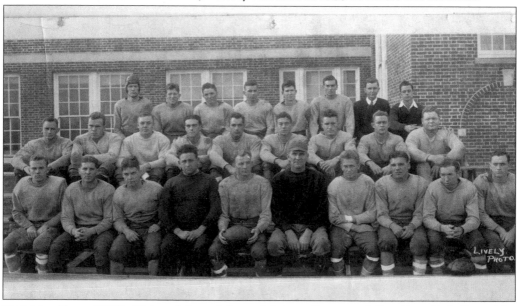

FOOTBALL TEAM, 1933. Pictured from left to right are (front row) Lee Pate, Bob Reynolds, Jack Thomas, Pap Cummings (assistant coach), Luther Smith (captain), F.A. Faulkinberry (coach), Bob Roth, Gray Sands, Herman Smith, and Oscar Cowly; (middle row) George Sharpe, Homer Pittard, Buck Edwards, Joe Wallace, Smartt Paris, Bill Carlton, Charlie Holt, Brownlow Sharpe, and Percy Bramblett; (back row) Marion Edney, Bill Bass, Raymond Merriman, Mickey McGuire, Charlie Kerr, Warpee Charles, Bob Ikaard (manager), and Deava Water (manager). Not shown is Red Owens.

State Teachers College

Murfreesboro, Tennessee

Dormitory Rules and Regulations

for

Young Women

1932--1933

GIRLS' DORMITORY RULES, 1932–1933. In addition to the nine rules, girls also had to abide by nine regulations. Young men could visit only on Fridays from 7 p.m. to 9:30 p.m. and on Sundays from 3 p.m. until 5 p.m. Girls were not allowed to sit in cars with boys. No electrical appliances could be used in dorm rooms and rooms were subject to inspection. Sunday afternoons from 1 to 3 were reserved for quiet time in the reception room, the student's own room, or space immediately around the student's own dormitory.

RULES

1. Young women have the privilege of going to town three times a week without permission, returning not later than 5:40 P. M. Young men may accompany young women to the picture show on these afternoons.

2. Young women must have written permission from their parents or guardian to go home over week ends, to leave school for visits to friends, relatives or to go to Nashville. Such permission must be mailed directly to the hostess, and must be received not later than Friday. The week-end extends from the LAST CLASS on Friday or Saturday, as the case may be, to the first class on Monday morning.

3. No young woman is permitted to go driving with a young man without permission and without proper chaperonage approved by the hostess. Arrangements to go driving with relatives may be made with the hostess.

4. Every young woman is required to register upon leaving the dormitory to go to town, for week-end visits home or elsewhere, to the boulevard store, and to any event that takes the student out of the dormitory after six o'clock at night, such as entertainments, club meetings, library, etc. When leaving the dormitory for a visit anywhere the young woman should leave the address or phone number of the place she is visiting. On returning to the dormitory she should check in.

5. Upon returning from ANY night event or engagement, young women must come into the dormitories at once.

6. Quiet must be observed in the dormitories during school hours and during the study period at night. The study period begins at 7 P. M. Visiting in each others rooms during study hours is not approved.

7. Lights must be out by 11 P. M.

8. Loud laughing, screaming, running in the corridors, calling or talking from windows are considered inappropriate for college women.

9. Card playing and dancing in the reception rooms are not approved.

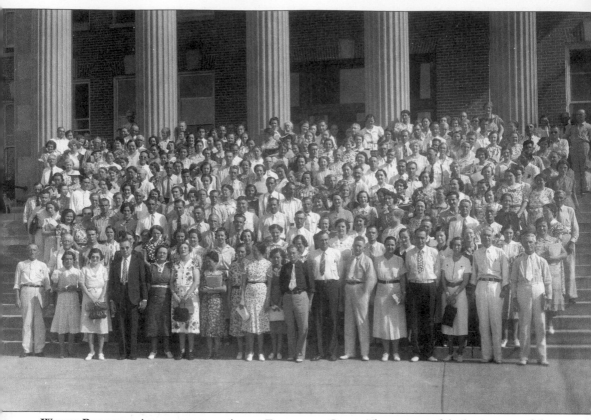

WORKS PROGRESS ADMINISTRATION ADULT EDUCATION CLASS. The campus felt the impact of the Great Depression and benefited from several of Franklin Roosevelt's New Deal programs, which generated jobs for the unemployed. WPA workers at STC improved landscaping and performed other manual labor. The program also hired out-of-work teachers, nurses, and dieticians to teach domestic skills.

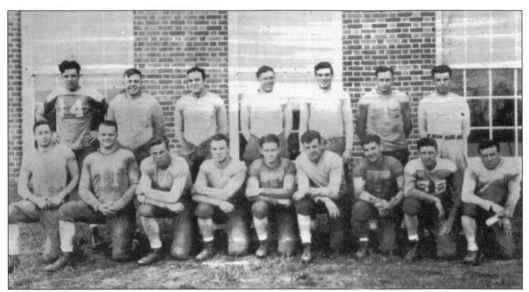

VARSITY FOOTBALL TEAM, 1934. Charles Gene Sarver, a guard on this team, won $5 in a contest naming the team the "Raiders" after the Colgate Red Raiders. Since STC team colors were blue and white, the local teams became the "Blue Raiders." According to Sarver, President Q.M. Smith and Public Relations Director Gene Sloan decided to add a mascot dressed as one of Confederate general Nathan Bedford Forrest's "raiders."

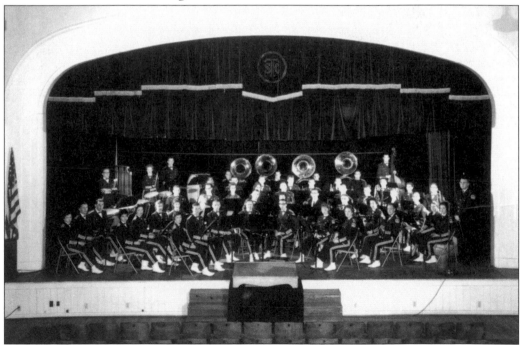

STATE TEACHERS COLLEGE BAND. A former student recalls that in 1941 the band played in the Columbia Mule Day parade, marching behind 5,000 mules! The band started in 1931 under the direction of Dr. W.M. Mebane, a chemistry and physics professor, who played baritone and cello. Tom Hewgley (student director), James Lokey, and Gabriel Valdes (the first paid full-time band director) followed him.

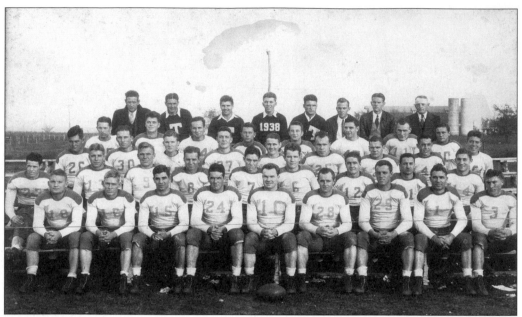

"First Undefeated Team," 1935–1936. Athletes often wore sweaters indicating the year of their graduating class.

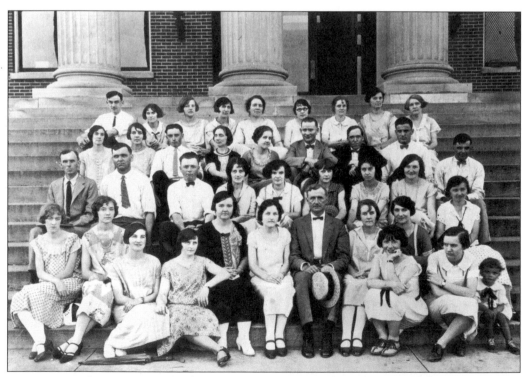

Unidentified Group, *c.* 1935. This is possibly a group of teaching certificate renewers on the Administration Building steps.

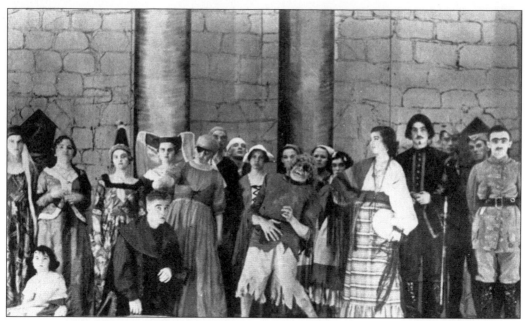

BUCHANAN DRAMATIC CLUB PRESENTATION OF *THE HUNCHBACK OF NOTRE DAME*, 1935. Drama club performances received high praise from former students. Offerings included *The Man Who Came to Dinner*, *Our Town*, *Abbies Irish Rose*, and *Romeo and Juliet*.

Admittance

TO PRESENTATION OF OSCAR WILDE'S

"Lady Windermere's Fan"

BY

State Teachers' College Dramatic Club

ON

Monday Evening, May 2—8 O'clock.

S. T. C. AUDITORIUM

DRAMATIC CLUB PERFORMANCE TICKET. Plays were popular campus events for students as well as faculty and townspeople.

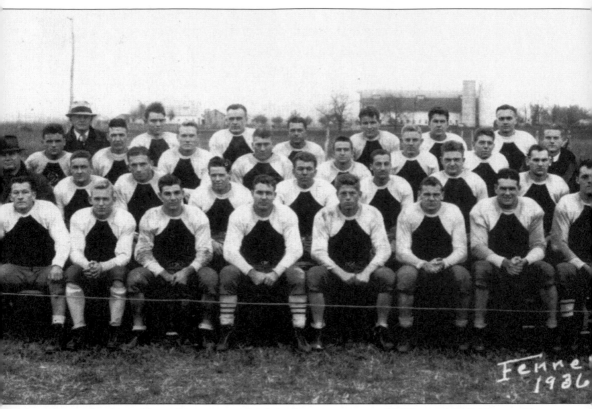

VARSITY FOOTBALL TEAM, WINNERS OF S.I.A.A. CHAMPIONSHIP IN 1935 AND 1936. Pictured here are, from left to right, as follows: (front row) Clifton Wiser, Everett McIntire, Clifton McGehee, Woodrow Smitherman, William McCrory, Nat Puckett, Brown Mims, and Joe Troop; (second row) Assistant Coach Zack Coles, William Hoover, Reed Hooper, Miles Baskin, Emmett Kennon, Robert Seay, H.L. Wasson, and J.B. Thompson; (third row) John Hambrick, Robert Bass, William Hoffman, Carter Smith, Edward Hessey, Norman Hasty, William Threlkeld, and Taylor Green (manager); (back row) Coach Johnny "Red" Floyd, James Hamblen, Wilson Summar, Clarence Campbell, Todd Jackson, Charles Miller, and Thomas Blair.

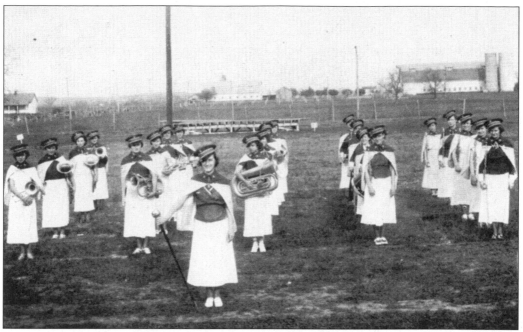

GIRLS' BAND, 1936. In addition to the band, mid-1930s clubs included Orchestra, Buchanan Drama, Debate, Home Economics, International Relations, "T", Association for Childhood Education, Rural Life, Writers, Tau Omicron (women's), Sigma (men's), YWCA, Physical Education, Women's Student Council, and Baptist Student Union.

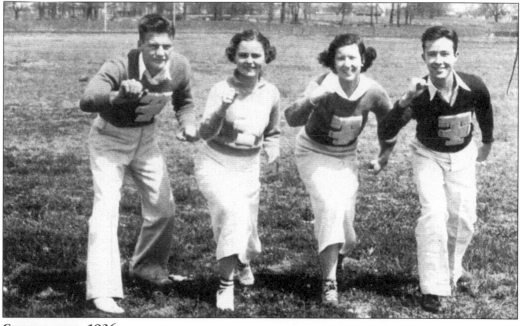

CHEERLEADERS, 1936.

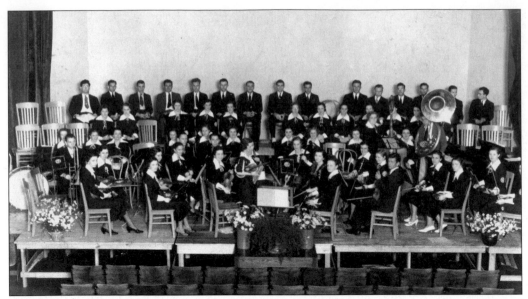

ORCHESTRA, *c.* 1935. Music was an integral part of student life during this era as evidenced by the number of musical groups and performances compared to other activities. The STC orchestra presented a variety of programs including classical concerts.

Ruth Hoover

State Teachers College

Murfreesboro, Tennessee

Student Dance Program

8 to 12

January 12, 1940

STATE TEACHERS COLLEGE

STUDENT DANCE

NO BREAKS

1. *Tom Townes*
 All the Things You Are

2. *Fount Watson*
 In the Mood

3. *R. E. Hill*
 Careless

4. *Mac Carter*
 It's a Wonderful World

5. *Haynie Bastian*
 Waltz Medley

6. *Randolph Stood*
 Billy

CAMPUS DANCE PROGRAM, 1940. Dances were very popular due to the limited social activities available.

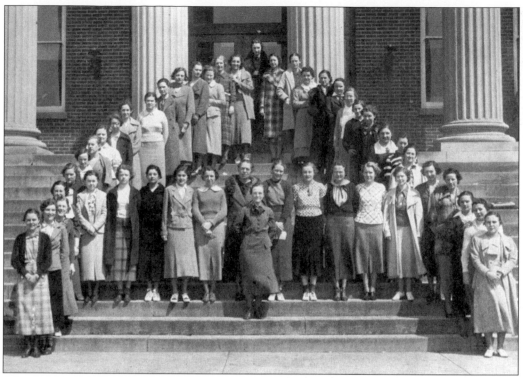

ASSOCIATION FOR CHILDHOOD EDUCATION, 1936. A branch of the national and state A.C.E. organizations, the group enhanced the training of elementary education majors. During World War II, many clubs' themes, such as "Home Economics in National Defense," related to the war.

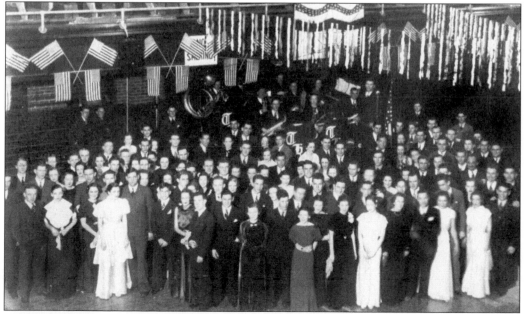

GEORGE WASHINGTON BALL, 1936. STC musicians provided the music for popular social events such as this dance that took place in the gymnasium.

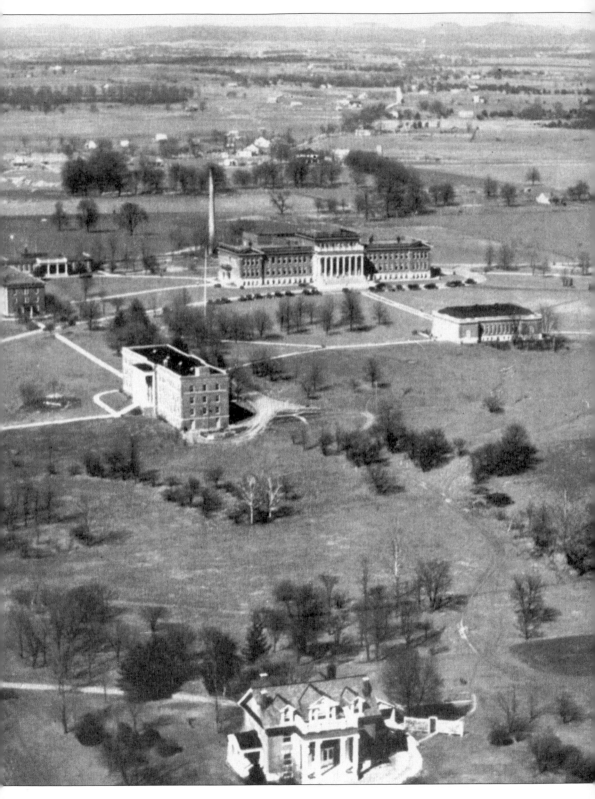

AERIAL VIEW, 1936. Landscaping was added during this era. One magnolia, in memory of Mrs. Maude Matthews, a former faculty member, was planted near the dining hall and others were planted elsewhere to honor the parents of Mrs. Rutledge.

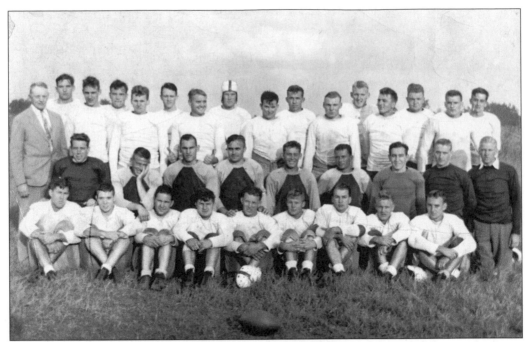

FOOTBALL TEAM, 1938. "[Coach] Johnny Red Floyd had only one losing season, a two and six record in 1938." (*They Bled Raider Blue*, 31.)

HORACE JONES FIELD, 1940. Jones Field was named to honor math professor Horace Grady Jones's "tireless efforts in the improvement of athletic facilities." (*First Fifty Years*, 50.) The new stadium could seat approximately 6,500. At the September 22 game against Jacksonville State "Every girl is required to bring a boy . . . A dramatic entry by our heroic Raiders . . . red, white and blue uniforms . . . white stars on their shoulders." Freshmen were required to go to the south end zone, throw their shoes into a pile; return to the north end zone, and run back down the field and try to find their shoes. The last to leave would receive "five licks each with the board." (*The Raider Forties*, 9–10.)

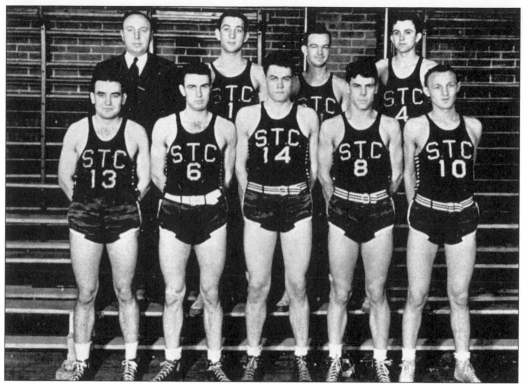

FRESHMAN BASKETBALL TEAM, 1940. Seen here from left to right are (front row) D. Smartt, M. Smartt, Brewington, Simmons, and Brandon; (back row) Coach Freeman, Fields, Lane, and Nunley.

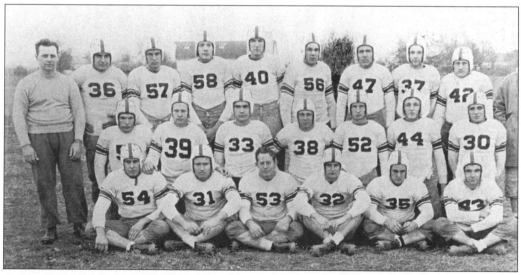

FRESHMAN FOOTBALL TEAM, 1940–1941. Due to the large number of male students involved in World War II, men's athletic teams were discontinued from 1942 through 1945. Rivalries developed between student teams and the military teams temporarily residing on campus.

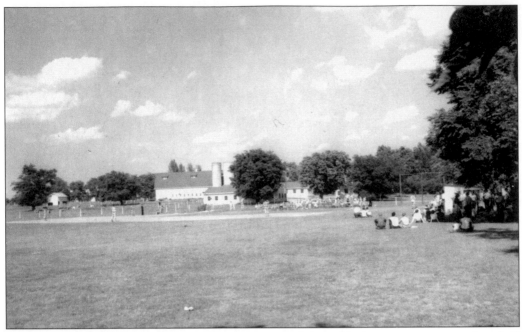

BASEBALL FIELD, 1941. As part of the expansion of the athletic program, a new baseball diamond was prepared in May 1940 beside the road to the college farm. Previous games were played in front of the Science Building.

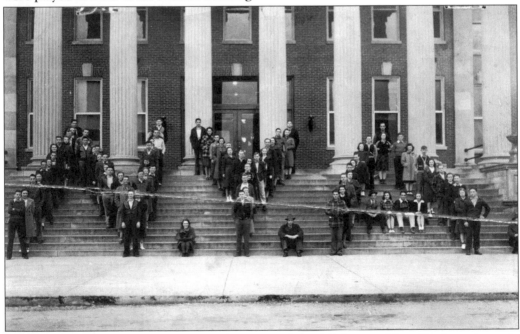

NATIONAL YOUTH ADMINISTRATION, 1940. Formed in 1939 as a New Deal work study program to assist students with college expenses, NYA projects included work on the football stadium, the cafeteria extension, and the air field and hangar. Although most students worked, Joe Nunley recorded that "The best deal of all is to be one of Leon Bibb's N.Y.A. boys."

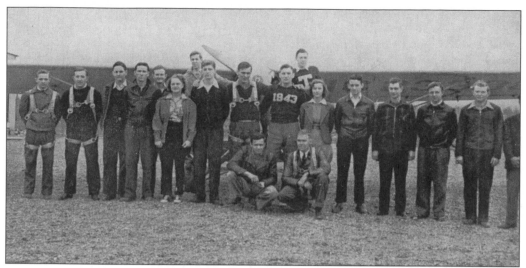

CIVILIAN PILOT TRAINING CLUB, 1941. The Civilian Pilot Training course began in June 1940 and within the first year a hangar was built. The goal was to provide students with training preparatory to flight and ground tests and licensing.

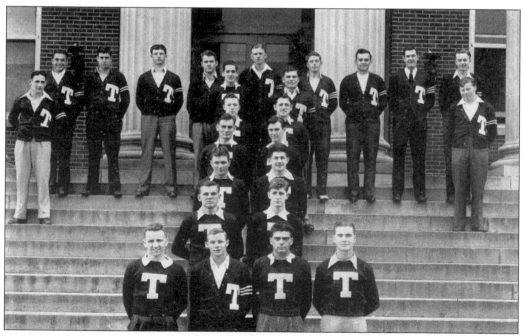

"T" CLUB, 1941. Male athletes who lettered in any major sport could join the "T" Club for social interaction and to improve athletic standards. In 1941, for example, the club sponsored an amateur night, a musical revue, a banquet, and dance for high school athletes from across the state.

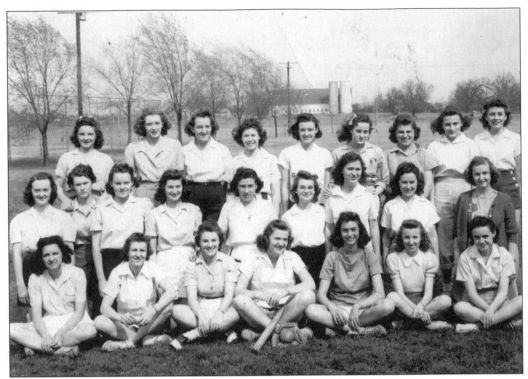

WOMEN'S SOFTBALL TEAM, 1941–1942. As enrollment of male students plunged during World War II, women's sports dominated campus recreational life.

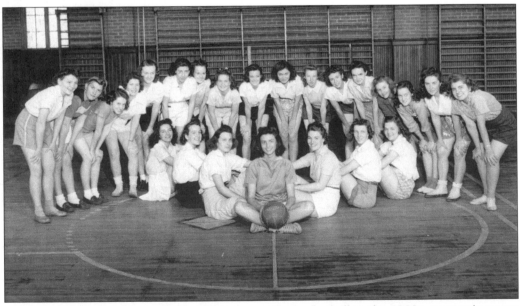

WOMEN'S VOLLEYBALL TEAM, 1941–1942. Except for basketball in the 1920s, women's sports were intramural in MTN and STC days.

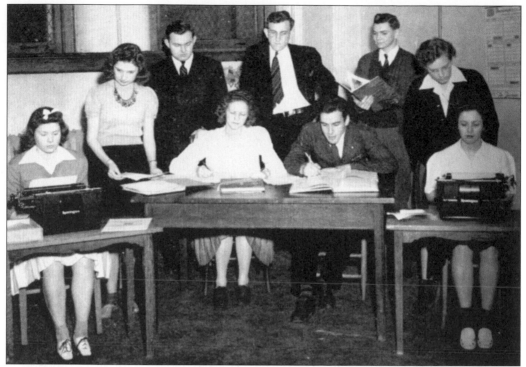

MIDLANDER STAFF, 1942. The *Midlander* yearbook debuted in 1926—one year after the campus newspaper, *Sidelines,* appeared.

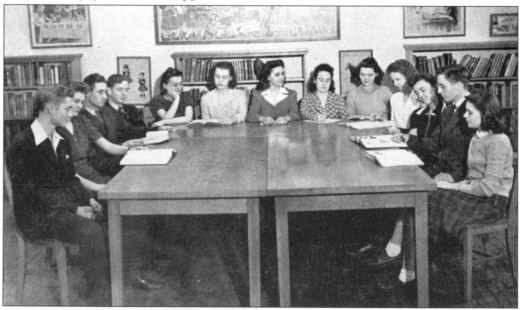

ASSOCIATED STUDENT BODY. Organized in 1939, the student governing body's structure mirrored that of our national government. The 1941–1942 Congress members pictured above were elected by the undergraduate student body with four representatives each from the senior and junior classes, three from the sophomore, and two from the freshman class. Only seniors could hold the offices of vice-president and president.

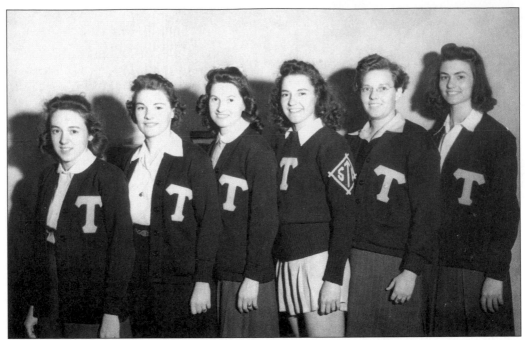

WOMEN'S ATHLETIC ASSOCIATION, 1942. Women qualified for membership in the WAA by earning 2,000 points in intramural competition. The club sought to develop good sportsmanship, cooperation, and an active interest in sports.

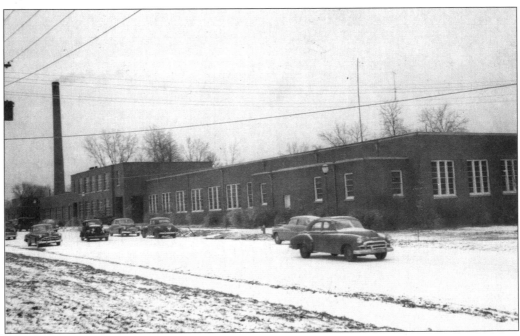

VOORHIES INDUSTRIAL ARTS BUILDING. Constructed in 1942, the building quickly became the focus of World War II support training.

MISS ELIZABETH SCHARDT. As a foreign language instructor, Miss Schardt taught Spanish and Latin American life "as a gesture toward Pan-American solidarity"—part of the college's contribution to World War II preparation. Other faculty members were reassigned to cover for those serving in the military and new courses were offered to meet the demand for engineering, mechanical, and aviation training. (*Daily News Journal,* September 1942.)

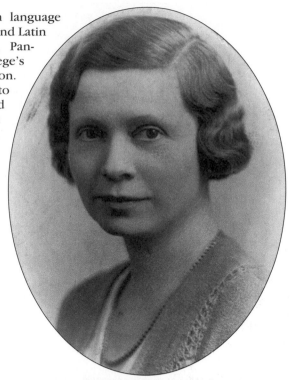

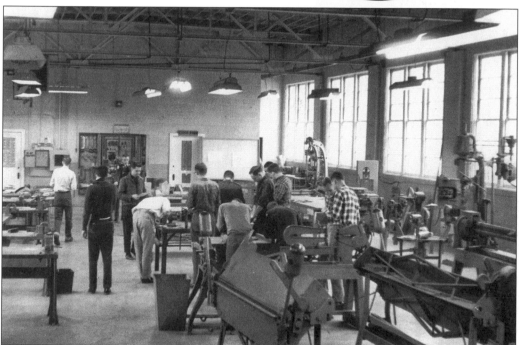

INDUSTRIAL ARTS DEPARTMENT. New equipment (installed in 1942) for the Industrial Arts Department was a critical component of the World War II training program. "The Shop" became a much busier place during STC days with the New Deal projects and World War II mobilization.

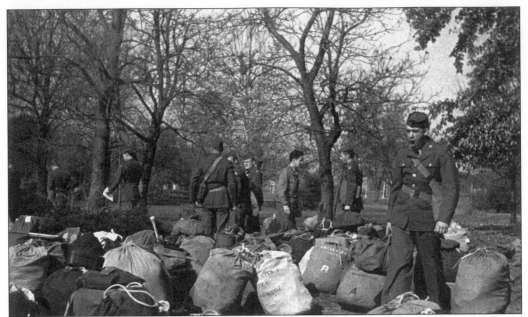

ELEVENTH COLLEGE TRAINING DETACHMENT (CTD). The college offered Army, Navy, and Marine reserve classes under contract with the federal government. Courses included engineering drawing, accounting, and mechanics. World War II duty called most of the male students away. By 1943 male enrollment (not including military training units) had dropped to 28 from the pre-war figure of 342.

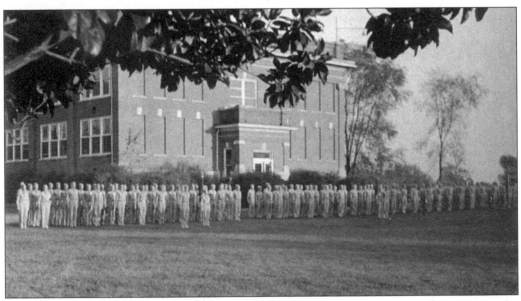

ELEVENTH CTD NEAR THE ADMINISTRATION BUILDING. Aviator trainees came from across the United States as part of the Tennessee State Board of Education's agreement with the federal government to provide academic and physical instruction. From the first of 1943 until the last CTD class left in July 1944, women resided three to a room in Rutledge Hall, leaving Lyon Hall for the military. Large crowds, including city residents, enjoyed watching the cadets' Sunday dress parades and drills.

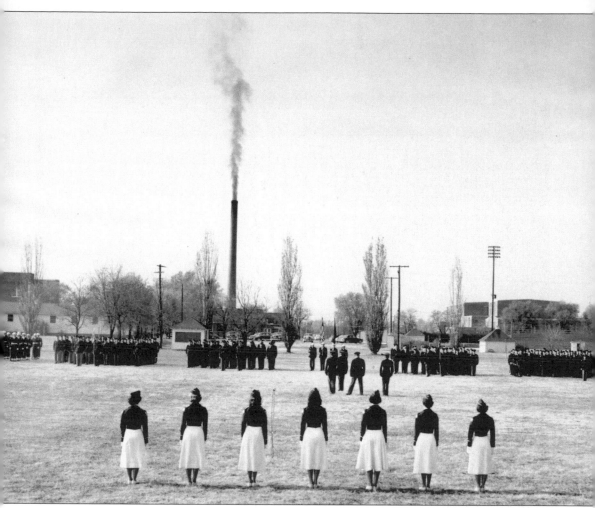

BATTALION REVIEW OF THE BRANCH GENERAL UNIT AT MIDDLE TENNESSEE STATE COLLEGE. Second lieutenants for the Army and Air Force and ensigns for the Navy received Reserve Officers' Training Corp commissions upon successful completion of their academic work.

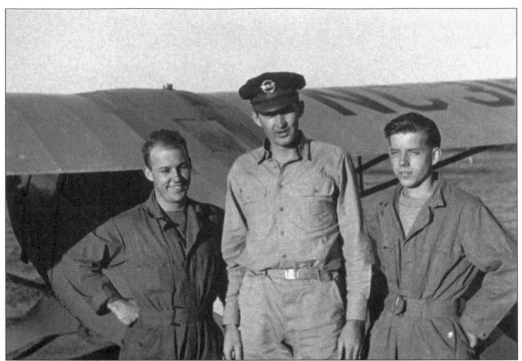

ELEVENTH CTD FLIGHT INSTRUCTION. The CTD also provided flight training. In July 1943, the 11th CTD initiated a twice-monthly newsletter called "Skylines," the contest-winning name submitted by W.E. Ourant.

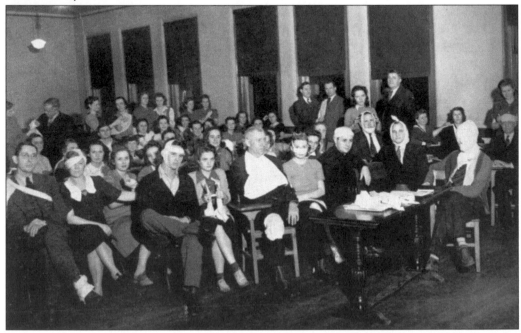

CIVILIAN DEFENSE TRAINING. Pres. Q.M. Smith chaired Murfreesboro's Civilian Defense Training program. Beginning in 1941, citizens participated in mock disasters to develop preparedness skills.

Three

MIDDLE TENNESSEE STATE COLLEGE
1943–1964

BECOMING A STATE COLLEGE, 1943. The student body had much to do with the push toward state college status at Middle Tennessee State Teachers College. One student wrote in an editorial in *Sidelines* that the student body should work together to "get rid of this tongue twisting paragraph that has heretofore been our name." Although the change was not approved officially by the state legislature until late 1943, it was announced to a joyous student body in 1942.

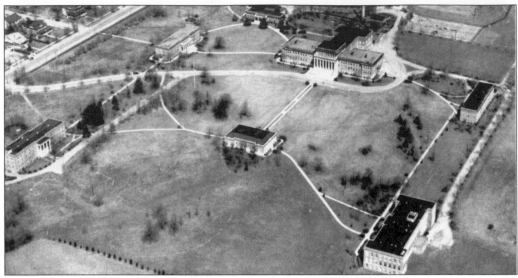

MTSC IN 1944. Although the state eventually decided on the geographic title for the college, several other names were considered. Coach E.W. Midgett thought that Forrest State College better represented the "Raiders." Stone's River State College and Murfreesboro State were also suggested. Shown here is an aerial photograph of the MTSC campus in 1944.

To Our Men and Women
In The Service

This number of the Side-Lines has been prepared especially for you, our former students who are in the armed forces of our country. It is small recognition of the work that more than six hundred of our men and women have done, are doing, and will do, but we hope that it will bring a bit of the campus to each of you wherever you are and will be one means of telling you how much we miss you and how proud we are of you. There is a great gap between the easy, carefree life that you led a few years ago and the hard life that you are now living. That you have been able to bridge the gap and to acquit yourselves with courage and valor is a tribute both to your high manhood and to the training that you received while here. We congratulate both ourselves and you on your ability to adapt yourselves so readily.

We hope that you will write to us as often as you can, not only because we want to hear from you, but also because we hope later to write a history of the contribution of our school to the war effort—a contribution that is largely your own. But whether or not we hear from you or you from us, you can always be sure that our thoughts are with you and our hopes are for your safety and speedy return.

SIDELINES **HONORS MTSC ALUMNI, 1944.** The *Sidelines* staff honored their former classmates with this message that appeared on the front page in January 1944.

WHEN JOHNNY COMES MARCHING HOME. In 1944, Congress passed the Serviceman's Readjustment Act (the GI Bill), which made federal funds available to veterans to complete their education. The U.S. Office of Veterans Affairs authorized MTSC's participation in the program in 1945. Subsequently, returning veterans pushed MTSC's enrollment to record levels. The student shown here is working in the industrial arts shop.

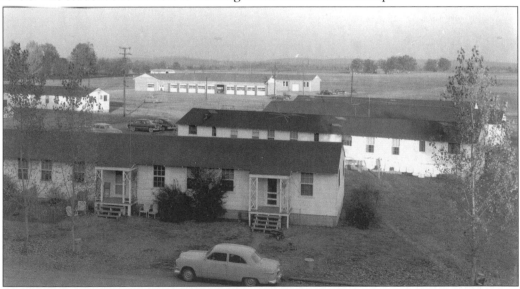

VET VILLAGE. Following the end of World War II, MTSC experienced tremendous growth as a result of the G.I. Bill. To meet emergency housing needs, in 1946 Congress appropriated $78 million to move buildings from military bases to college campuses. MTSC also received federal funds to erect small apartments for married veterans and their wives and children. Vet Village, as this area of campus was known, had its own laundry house, student-run grocery store, mayor, and representative on the Associated Student Body.

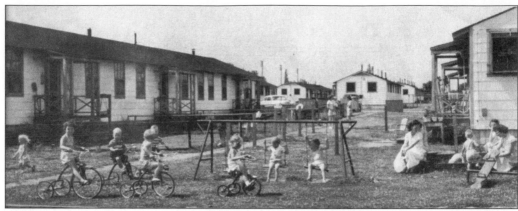

HOME SWEET HOME. According to a brochure from the late 1940s there were "107 apartments and trailers for married veterans with a playground for the youngsters. Clean and convenient cafeteria and lunchroom services are on the campus. Recreation halls for informal gatherings are convenient to both the veterans housings and the dormitories." Each trailer was equipped with a small kitchen, living area, and bedroom. A washhouse was located nearby. Vet Village and the GI Bill provided opportunities to attend MTSC for people who could not have done so without assistance.

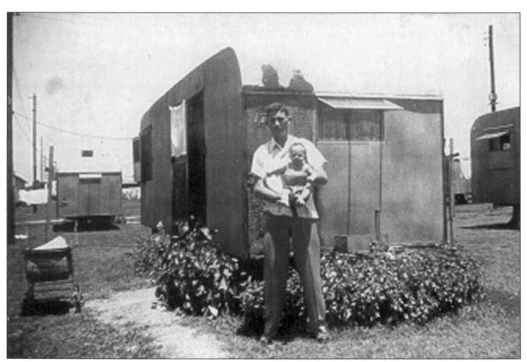

PROUD FATHER. Navy veteran Jerry Gaither holds his five-month-old daughter Maxine in front of their home in Vet Village in 1950. Gaither joined the Navy immediately after high school and later used the GI Bill to attend MTSC. (Courtesy of Jerry Gaither.)

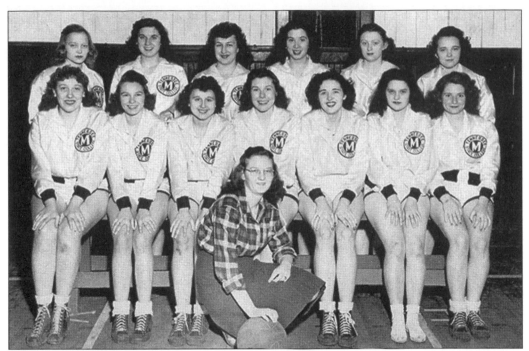

THE BLUE RAIDERETTES, 1946. Coach Nance Jordan led the Blue Raiderettes to the Southeastern AUU tournament. Pictured, from left to right, are (front row) Mary Ann Zumbro, Betty Cloyd, Nancy Aikman, Betty Hart (captain), Faye Kent, Jacquelyn McMurtry, and Imogene Queen; (back row) Sarah Mazwell, Beatrice Thurman, Mary Ellen Roberts, Jane Brandon, Louise Arnold, Jane Bratee, and Dollye Cardwell.

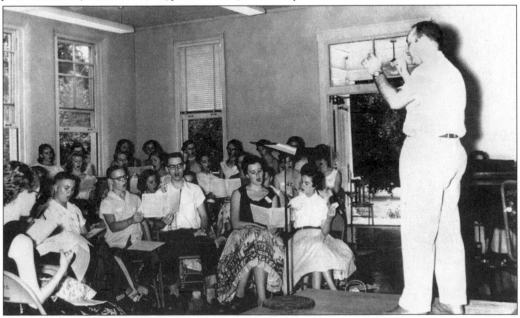

NEIL WRIGHT DIRECTING STUDENTS. E. Mai Saunders made up the music faculty from 1911 to 1946 when the husband-and-wife team of Neil and Margaret Wright were hired to expand the music program.

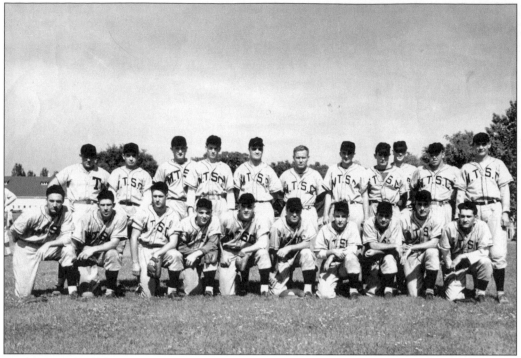

BLUE RAIDERS BASEBALL, 1947. Coach Nance Jordan led MTSC baseball in the postwar years. The team soon became a major force in the Volunteer State Athletic Conference, winning championships in 1949, 1950, and 1951.

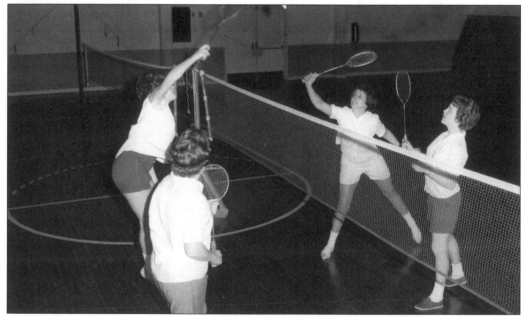

WOMEN'S INTRAMURAL SPORTS. Although women's sports did not receive the same attention as men's sports, the intramural sports program was quite diverse. Female students could participate in sports such as badminton, basketball, dance, golf, gymnastics, soccer, softball, swimming, table tennis, touch football, and volleyball.

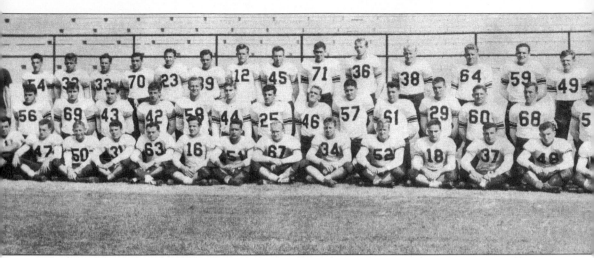

UNDEFEATED TEAM, 1949. Coach Charles "Bubber" Murphy, an MTSC alumnus, began his MTSC coaching career in 1947. He led the Blue Raiders to four undefeated seasons and conference championships in 1947, 1949, 1950, 1951, 1956–1959, 1962, 1964, and 1965.

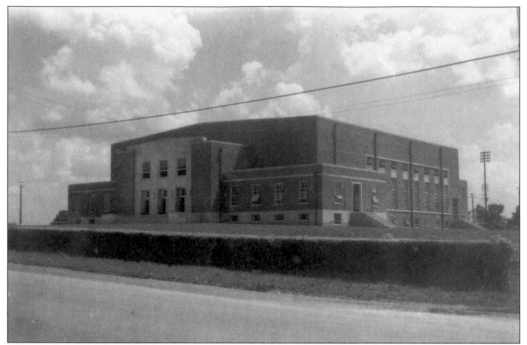

ALUMNI MEMORIAL GYMNASIUM. Completed in 1950, the Alumni Memorial Gym was dedicated to all MTSU alumni who lost their lives in World War II. In addition to housing sports and recreation programs, the gymnasium also served as the principal venue for graduation and student programs.

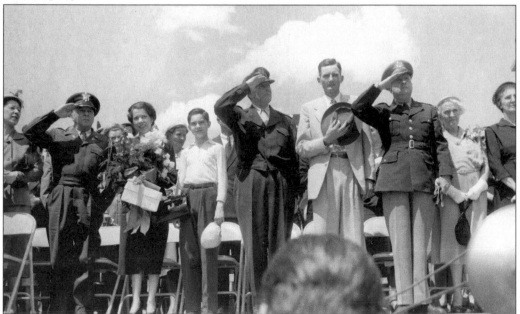

THE MACARTHURS' VISIT TO MURFREESBORO AND MTSC. Gen. and Mrs. Douglas MacArthur (on the left) are saluting at a ceremony held in the campus football stadium in honor of Mrs. Jean MacArthur's return to her hometown in 1951. The stadium filled to capacity for the event as the citizens of Murfreesboro welcomed the celebrities.

Union Building, 1952. The Union Building was completed in 1951. Renamed in 1978 to honor the first dean of students, Clayton L. James, the building served as the hub of student activity for over 20 years.

Three Students Strolling Past the Murfree Building. The Murfree Building housed the English department in the 1950s. It was torn down and replaced by Peck Hall in 1968.

THE FIRST GRADUATE STUDENTS AT MTSC, 1952. From left to right are William Leavitt, Clay Colde, Gordon Traver, Guy A. Scott, Thomas G. King, and N.A. Link. The graduate program began in 1952 under the direction of Pres. Quintin Miller Smith. Restricted to education majors, the program originally took only one year to complete. The degree included minors in social science, English, industrial arts, and science. By 1965, areas of study included educational administration, guidance and counseling, health, physical education, mathematics, and science.

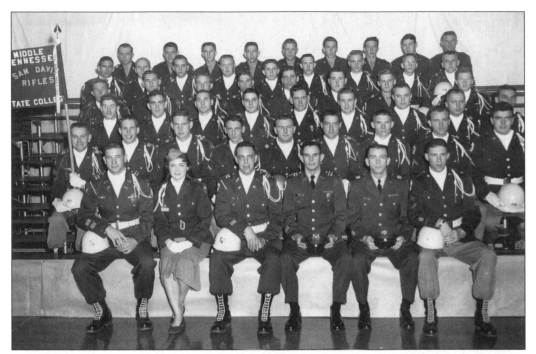

SAM DAVIS DRILL TEAM AT ATTENTION. The team began in 1953 as a part of the ROTC program and was a favorite at football games for nearly 20 years. Today the precision drill team is known as the Blue Brigade. In 1955 the ROTC program became mandatory for all freshmen and sophomore men.

MTSC BASKETBALL, 1953–1954. Pictured from left to right are Dick Bratton, Doug Shrader, Doris Jones, Tommy Griffith, Gerald Johnson, Render Carden, Joe Burks, Tom Hogshead, Sammy Smith, Hal Christiansen, John Prices, Ralph Sellers, Ken Trickey, George Stoter, and (kneeling) Coach Charlie Greer. The team entered their second year of Ohio Valley Conference play confidently. Although the Raiders ended up with a record of 12 wins and 17 losses, the team had a first-round victory over Murray State in the OVC tournament. (Courtesy of Joe Smith.)

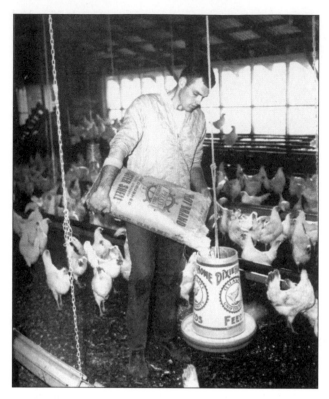

A Farmer's Life. An agriculture student feeds chickens on the MTSC farm in 1954. Students from the Agriculture Department performed daily chores to gain practical experience. Campus dining facilities used the eggs and milk produced on the farm to feed the school's 1,600 students and sold the excess to community residents.

Aviation. ROTC students David Kinney, John Fuqua, Ray Weatherspoon, Eddie Alexander, and instructor Miller Lanier prepare their flight plan. The Aviation Department continued after Air Force training units left the campus in 1944. The aviation program remained on campus until 1954, when increased usage of the campus airport caused Miller Lanier, the flight instructor, to lease space at the Murfreesboro Municipal Airport. The Aerospace Department continues to offer pilot training. (Courtesy of Joe Smith.)

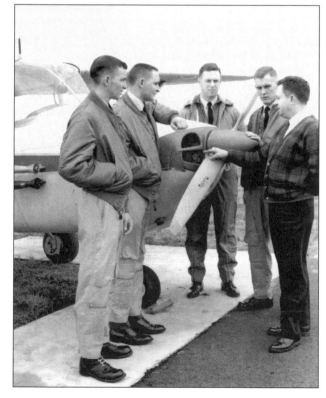

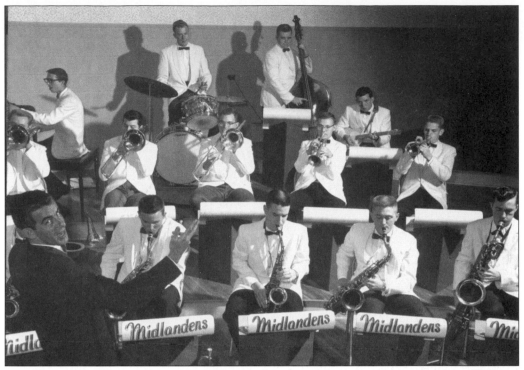

THE MIDLANDERS SWING BAND. The Midlanders, a campus jazz and dance band, was formed in 1956. The band served both entertainment and academic purposes by playing for social functions and helping to train musicians. The Midlanders were a favorite on Fun Night, a weekly dance held on Tuesdays in the Union Building.

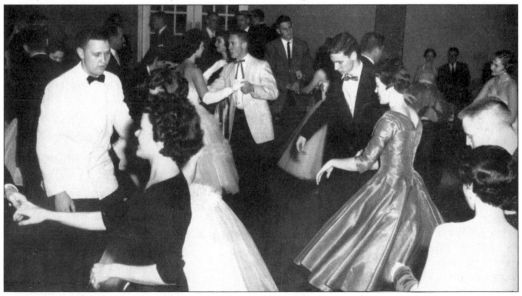

STUDENTS AT A FORMAL DANCE, 1957. Male students could not keep their dates out too late since female students had "house mothers" who enforced a curfew (men did not have curfews). During this time, all women students were required to reside on campus under close supervision. Men could live off campus.

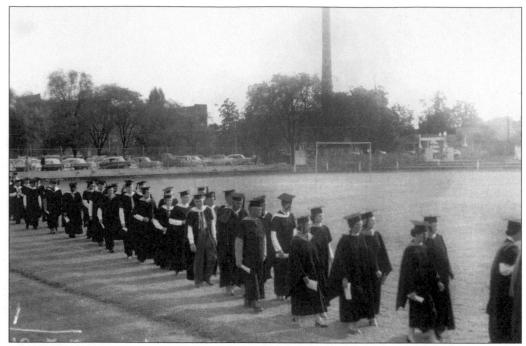

GRADUATION, 1957. Professors make their way to commencement in August 1957. In 1959, the administration introduced the semester system rather than quarters for the first time in the school's history, reducing the number of graduation ceremonies held each year. Commencement ceremonies were held outdoors or in Alumni Gym until the larger Murphy Center opened in 1972.

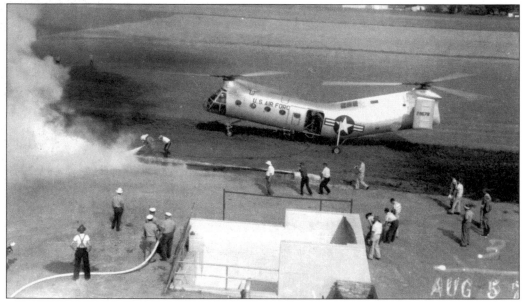

STATE FIRE TRAINING SCHOOL, 1957. MTSC was home to the Tennessee State Fire School beginning in 1944. Firefighters and fire chiefs from all over the state would convene on the MTSC campus to learn about fire prevention and protection. Students pictured here were learning techniques on how to fight fires caused by airplane crashes.

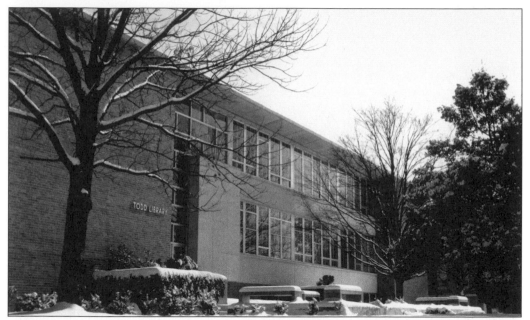

TODD LIBRARY ON A SNOWY DAY. By 1958, Vet Village had been dismantled and a new library was built on the site. The library was named for Andrew Todd, a local businessman and member of the Tennessee State Board of Education who had led the original campaign to have the legislature locate Middle Tennessee Normal School in Murfreesboro.

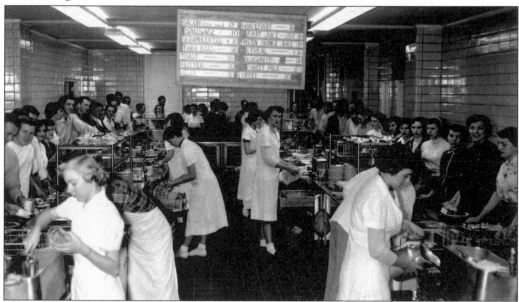

LUNCHTIME RUSH, 1959. Student workers help prepare lunch as other students wait. Slater Food Service, a commercial catering business, took responsibility for the cafeteria, the Terrace Room, and banquets and other special events in 1957. This service replaced many years of family-style cafeteria management that began with Mrs. Clint A. Taylor, who served boardinghouse-style dinners and sack lunches beginning in 1911. The commercial service proved more efficient at meeting the needs of a student body that had increased nearly 700 percent since the school's founding.

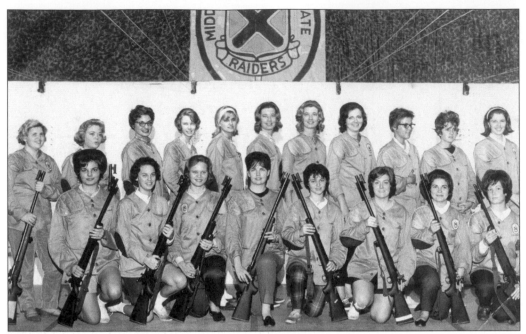

RAIDERETTE RIFLE TEAM. The Raiderette rifle team was founded in 1959.

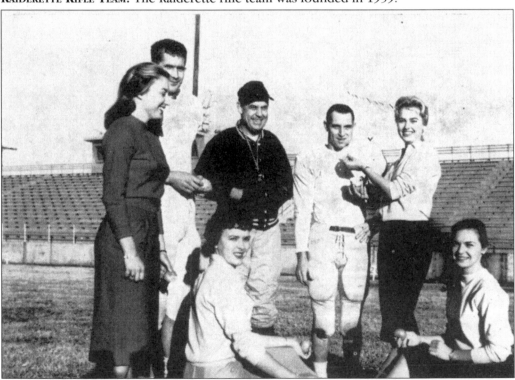

THE TANGERINE BOWL, 1959. For the first time in MTSC history the football team participated in a major bowl game in 1959. On December 31, in the Tangerine Bowl in Orlando, "Bubber" Murphy led the Blue Raiders to victory over Presbyterian College of Clinton, South Carolina. The score was 21-12.

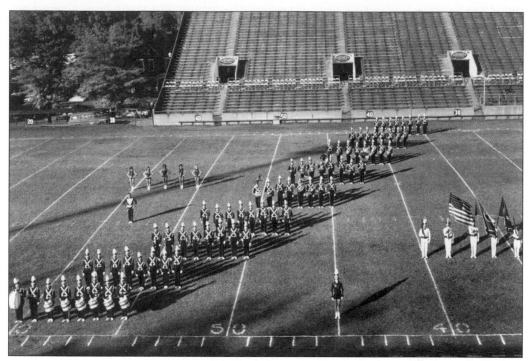

THE BAND OF BLUE. Under the leadership of Joseph Smith, the Band of Blue experienced great success with performances at the Tangerine Bowl in 1959 and 1961, a half-time show during a 1965 Washington Redskins-Dallas Cowboys game, and the 1966 Kentucky Derby. Smith also began the Contest of Champions, a well-known competition for the best high school bands in the Southeast.

HOME ECONOMICS. Students polish some of the skills they learned in a home economics class. In 1959, MTSC established a Vocational Home Economics program, under the direction of Miss Margaret Putman. During the Normal School period, a "Domestic Science" department had aimed to prepare good wives and mothers. The new program in Vocational Home Economics, however, sought to prepare teachers of home economics, home demonstration agents, home economists for businesses, school lunch supervisors, and social workers. (Courtesy of Joe Smith.)

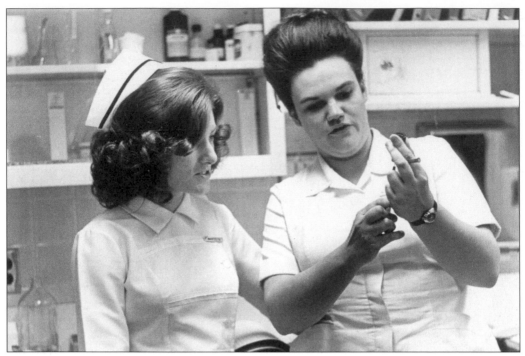

MTSC Nursing Program. Nursing students Diane Lee and Betty Jones both graduated from the associate degree program at MTSC and went on to work at the Rutherford County Hospital.

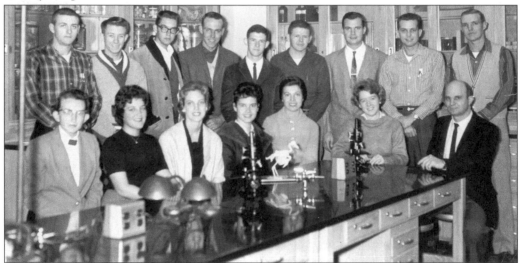

Biology Club, 1961. Before Greek organizations were allowed on campus in the late 1960s, departmental and honorary organizations were the primary social groups for students. Each year the Biology Club sponsored Stunt Night, during which campus groups competed against each other by performing skits. Pictured, from left to right, are (front row) Dorothy Doggett, Sarah Frances Wharton, Marilyn Marschel, Jo Ann Hughes, Nancy Anderson, Mary Lou McKnight, and J. Gerald Parchment (sponsor); (second row) J.H. Oldham, B.H. Hardwick, R.T. Derryberry, Ralph Johnson, Roger R. Sanders, Mack Davis, Edward L. Snoddy, Harold T. Sansing, and Bob McGhee. (Courtesy of Biology Department.)

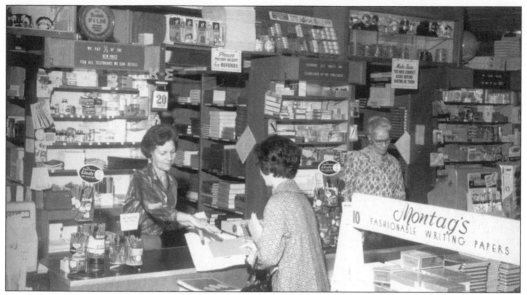

THE BOOKSTORE. "Do you have theme paper, toothpaste, size 32 sweatshirt, easy to understand outline series, ready-made tests?" (*Midlander*, 1961.) The bookstore, in its former location at the James Union Building, advertised that it stocked everything necessary for the college student. After relocating to the Keathley University Center in 1967, it was renamed the Phillips Bookstore after longtime manager Charles Phillips. (Courtesy of Phillips Bookstore.)

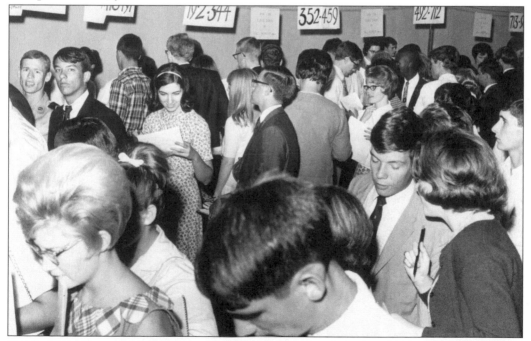

THE LENGTHY REGISTRATION PROCESS. Registration for classes in the MTSC was a long process that required patience. Students waited in separate lines for each class in which they wished to enroll. While tedious, registration also was a good time to catch up with friends after summer break.

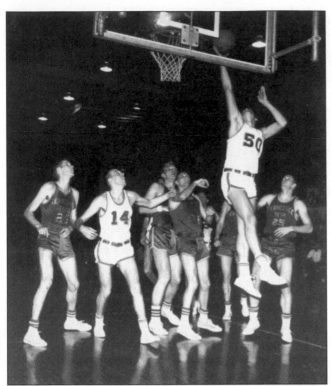

BLUE RAIDERS AND RIVAL TENNESSEE TECH. The rivalry between the Blue Raiders and Tennessee Tech's Golden Eagles dates back to 1917.

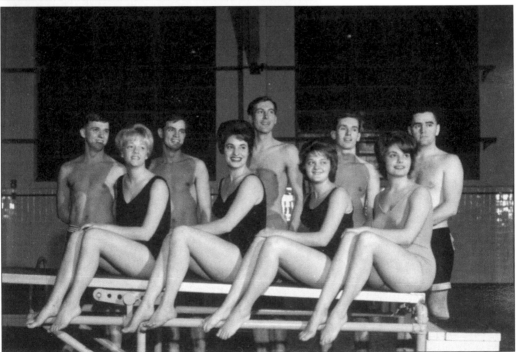

THE TRITON CLUB. The Triton Club was a synchronized swimming team that held an annual water show. Each year the group showed off its swimming talents, while promoting water safety. (Courtesy of Joe Smith.)

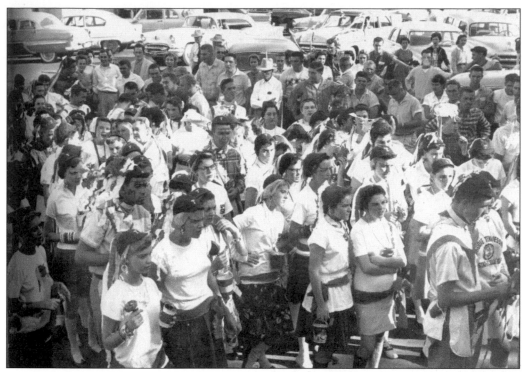

FRESHMEN ORIENTATION. For many years, the university has offered freshmen an opportunity to arrive on campus early and get a feel for their new surroundings before plunging into their first semester.

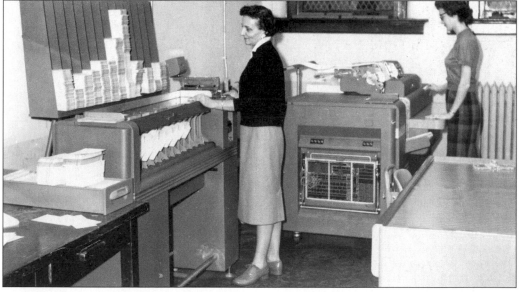

IN "THE LAIR OF THE BEAST." This early IBM card reader, sorter, and printer made registration and other administrative duties more efficient. In order to facilitate efficiency, MTSC was organized into a system of schools in 1962. In 1991, the university's six schools became colleges. In 1998, the honors program became the first Honors College in the state. (*Midlander*, 1961.)

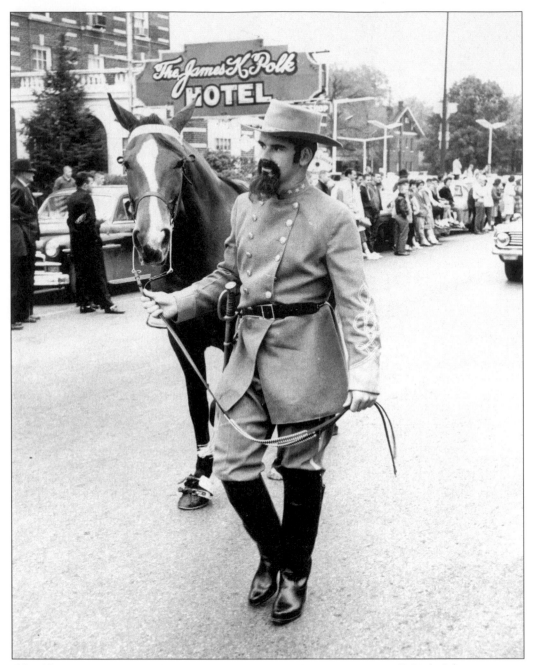

"**THE TWENTIETH CENTURY COUNTERPART OF NATHAN BEDFORD FORREST.**" Dick Schooman was
the Blue Raider in 1961; he is seen here marching in the homecoming parade. The 1961
homecoming also saw the dedication of a new MTSU flag and a new alma mater.
(*Midlander*, 1961.)

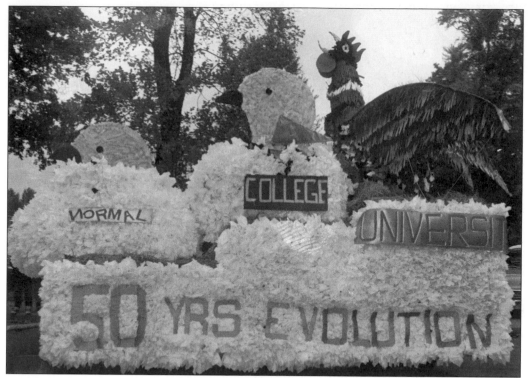

NORMAL, THEN COLLEGE, WHY NOT UNIVERSITY? Students during homecoming in 1961 already see university status as the natural evolution for the former normal school. Students welcomed the move to university status, just as students had supported the previous changes in status and name in 1925 and 1943.

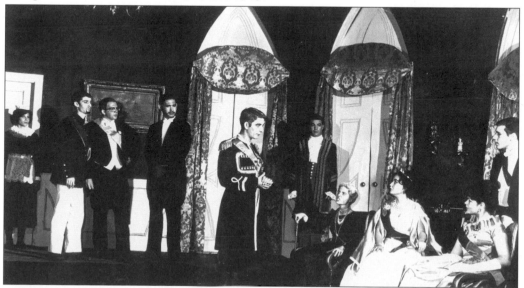

THE BUCHANAN PLAYERS, 1963. The Buchanan Players, a theater arts group and one of the oldest student organizations on campus, perform in a three-act play called *Anastasia*. Members of the Buchanan Players gained experience in acting, stagecraft, makeup, lighting, and directing. (Courtesy of Joe Smith.)

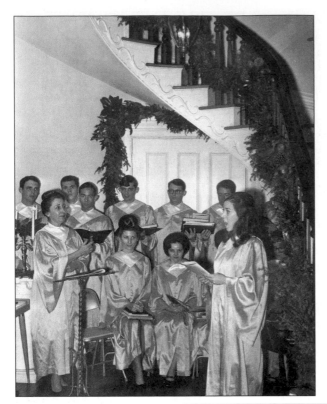

THE SACRED HARP SINGERS, C. 1963. Margaret Wright founded The Sacred Harp Singers in 1947. The group was renowned for their madrigal style of singing. Dressed in choir robes, the Sacred Harp Singers performed English folk songs, hymns, Southern folk songs, and ballads. The group received state and national recognition for their interpretation of the traditional folk art sound.

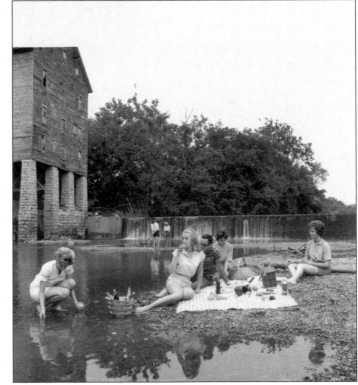

SUMMER STUDENTS ON A BREAK FROM THEIR STUDIES. Students, including Gov. Buford Ellington's daughter Anne Ellington, enjoyed an afternoon at the dam at Walter Hill while attending summer school in 1963. (Courtesy of Joe Smith.)

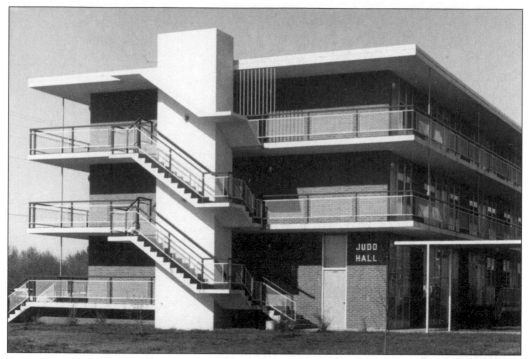

JUDD HALL. Judd Hall reflects the influence of modern architecture on the MTSC campus during the 1950s and 1960s

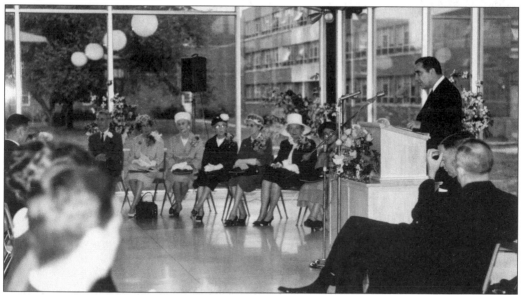

DEDICATION CEREMONY. MTSC experienced such a rapid expansion of campus facilities during the 1950s and 1960s that the school did not hold a dedication ceremony for each new building. At the ceremony pictured above, Gov. Frank G. Clement honored individuals for whom campus buildings were named during the year 1964. Seated, from left to right, are B.B. Gracy, Miss Mary Hall, Mrs. Bonnie McHenry, Mrs. W.B. Judd, Miss Tommie Reynolds, Miss Elizabeth Schardt, Miss E. Mai Saunders, and hidden from view behind the podium is T.B. Woodmore.

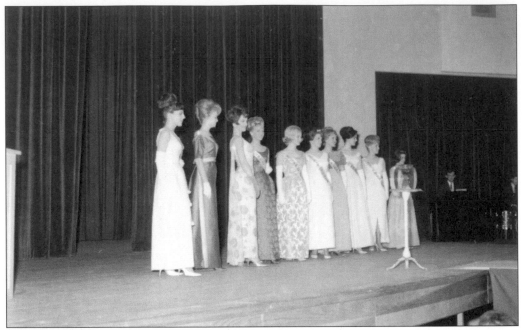

MISS MIDLANDER PAGEANT, 1965. Winner Mandy Gentry and other contestants appear on stage in the first Miss Midlander Pageant produced by the yearbook staff. Previously, the Miss Midlander Contest had been a part of the Biology Club's annual Stunt Night. (Courtesy of Joe Smith.)

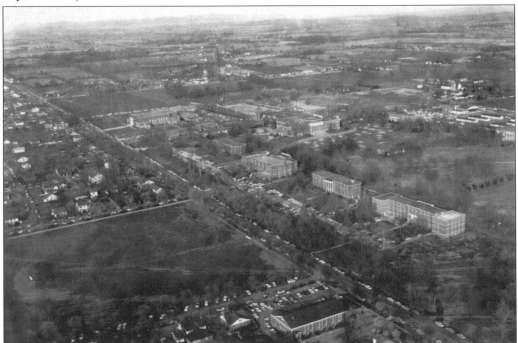

AERIAL VIEW OF THE CAMPUS. As the MTSC days drew to a close, the campus had more buildings and more students than ever before. By 1965, enrollment reached 6,000 and many recently constructed buildings dotted the landscape.

Four

MIDDLE TENNESSEE STATE UNIVERSITY

1965–PRESENT

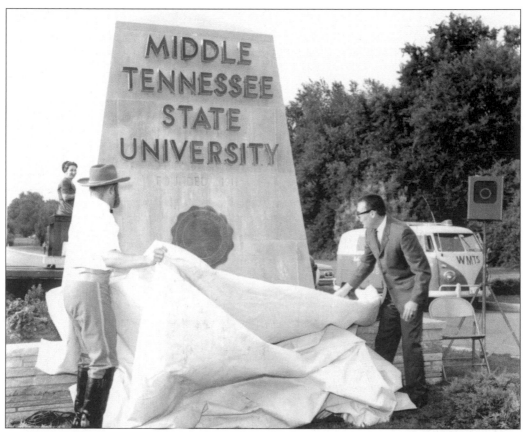

UNIVERSITY DAY. The Blue Raider mascot and ASB president Bert Wakeley unveil the entrance marker on July 1, 1965 that bears the school's new name, Middle Tennessee State University. (Courtesy of Joe Smith.)

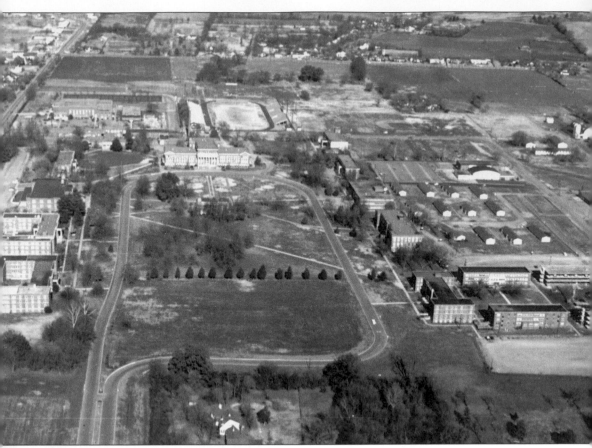

THE P-SHAPED LOOP. When Quill Evan Cope assumed the presidency in 1958, he continued the building program and had a scenic access road built as part of a campus beautification program. The new thoroughfare allowed visitors entering campus to pass each building. According to Homer Pittard, it "provided, for the first time, an opportunity to view the broad vistas of the campus described by many as the most beautiful in the state." The impact of the automobile was so evident on campus that several new parking lots were necessary and for the first time freshmen were not allowed to keep cars on campus.

Cope Administration Building. Cope Administration Building, named for university president Quill Evan Cope, opened in 1965. Cope continued Pres. Quintin Miller Smith's building program and carried the college to university status. The fourth president also continued fiscal policies that provided a sound basis for growth. President Cope initiated a campus beautification program and oversaw the construction of 23 new buildings, including the Keathley University Center, Ellington Human Sciences building, Saunders Fine Arts, and many new dormitories.

An Enthusiastic Cheerleading Squad, *c.* **1965.** The Blue Raiders football team went undefeated in 1965 and Coach Charles "Bubber" Murphy was named Ohio Valley Conference Coach of the Year.

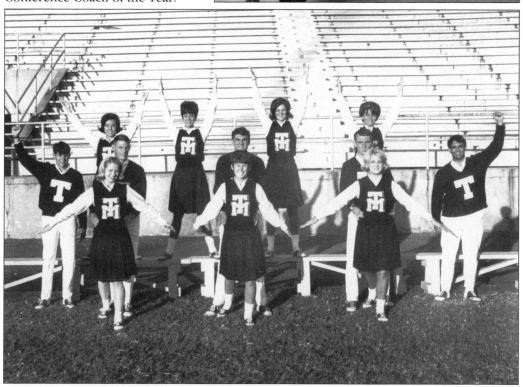

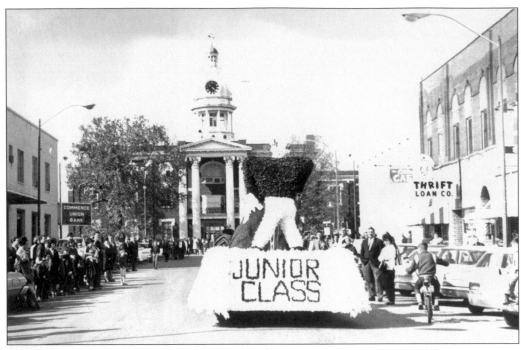

LOOK OUT MURFREESBORO. The junior class's homecoming float makes its way to the square as a part of the annual homecoming parade.

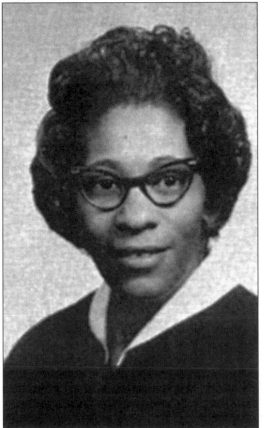

INTEGRATION AT MTSU. Although a potentially explosive issue, integration at MTSU was relatively peaceful. Olivia Woods was the first African-American student to graduate with a bachelor's degree from MTSU. An elementary education major, she graduated in 1965.

RELAY TEAM, 1965. The MTSU track program started in 1955 but did not gain a real reputation until Dean Hayes took over in the fall of 1965. Track was the first integrated sport at MTSU, and quarter-miler Robert Mallard, pictured here, became the first African-American athlete at MTSU. (Courtesy of Joe Smith.)

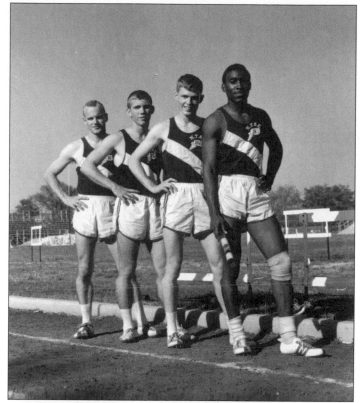

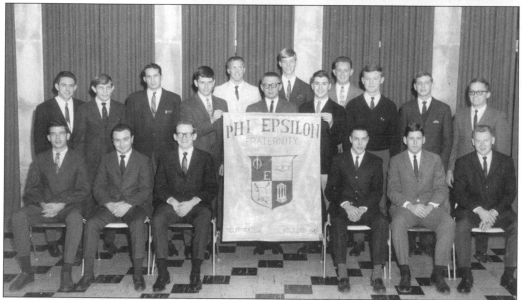

FIRST GREEK FRATERNITY, 1965. Since MTSU's administration did not previously recognize Greek organizations, members—fearing expulsion or loss of scholarships—went underground, keeping their membership secret. After Phi Epsilon petitioned the state to become a chartered non-profit group, MTSU recognized them. Phi Epsilon later became a chapter of the national Kappa Alpha fraternity.

VIETNAM SUPPORT PETITION. Harold Smith, 1965 ASB vice-president (left); Tom Peterson, freshmen class president (center); and Bert Wakeley, ASB president (right) hold a signature-filled paper showing student support for the servicemen and women in Vietnam. The petition was presented to Gov. Frank Clement, who gave it to Pres. Lyndon B. Johnson, who then sent it on to the Armed Services in Vietnam.

STUDENTS RALLY FOR PEACE. Opinion regarding American involvement in Vietnam was divided. Students opposed to the war rallied in front of the Keathley University Center. Like universities all over America, MTSU experienced a time of turbulence during the late 1960s. Students also expressed opposition to the draft, compulsory ROTC, dress codes, and dormitory regulations, particularly the more restrictive rules placed on women.

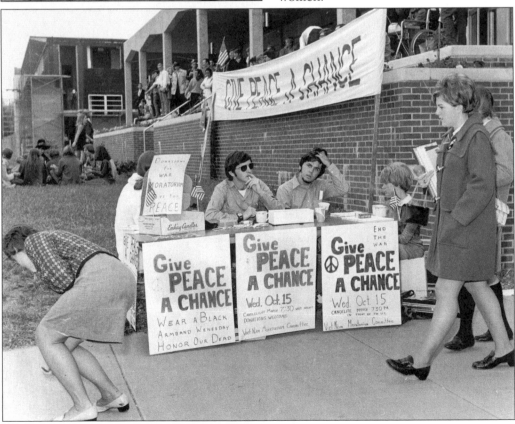

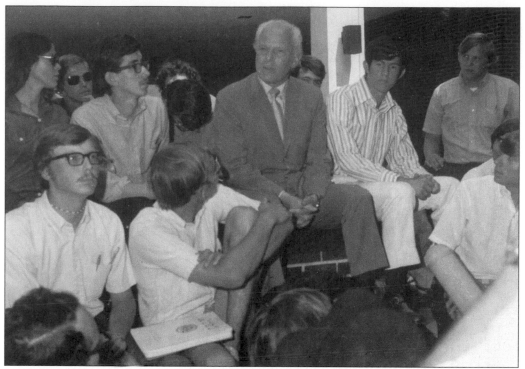

A Senator Returns Home. Sen. Albert Gore Sr. ('32) visits with students. Gore served in the U.S. House of Representatives from 1939 to 1953 and in the Senate from 1953 to 1971. He was best known for co-authoring the Interstate Highway Act (1956), for his support of civil rights, and for his opposition to the Vietnam War.

Blue Raider Baseball Team, 1966. Coach Jimmy Earle led his alma mater for the first time in the 1966 season.

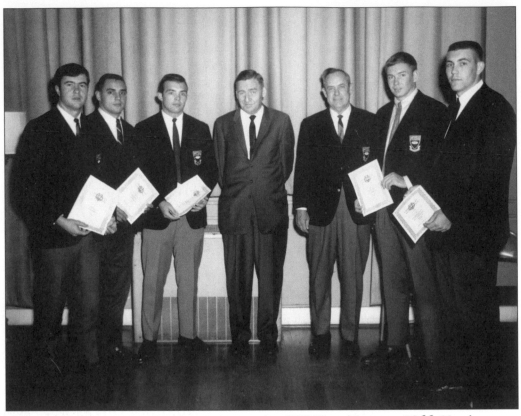

ALL OVC TEAM MEMBERS, 1966. Members, from left to right, are Steve Edging, Bob Hlodan, Larry Dotson, President Cope, Coach Charles "Bubber" Murphy, George Claxton, and Frank Victory. Successful coach Bubber Murphy (a 1938 STC graduate) led the Blue Raiders during the golden days of MTSC football. Murphy left as head coach in 1968 but remained as athletic director until his retirement. (Courtesy of Frank Victory.)

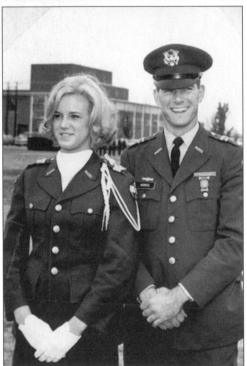

JAVENA ARMSTRONG, SPONSOR OF THE 1966–1967 ROTC BRIGADE, WITH BATTALION COMMANDER CADET MAJ. BUD MORRIS. The ROTC program at MTSU continued its success throughout the 1960s. It was the cause of contention, however, because many students believed that it should not be mandatory. (Courtesy of Bud Morris.)

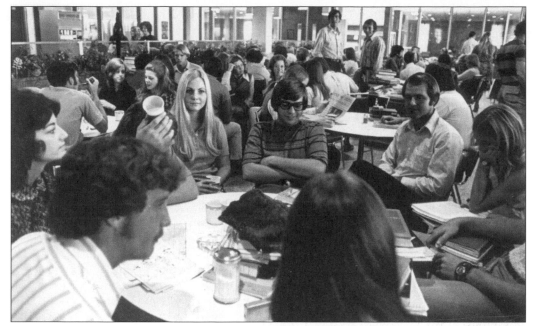

THE GRILL. The University Center was named after Belt Keathley, a professor of education, dean of students, and director of Student Financial Aid. The center has been the hub of student activities since 1967. It contains the Grill, pictured here, as well as Phillips Bookstore, the campus post office, a movie theater, the student affairs offices, and the offices of the Student Government Association.

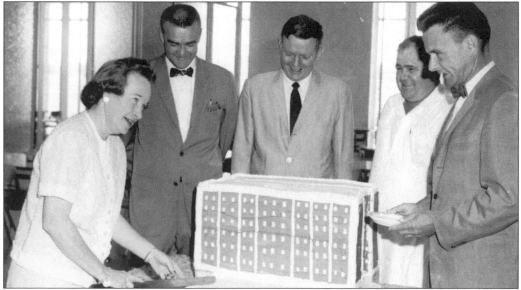

OPENING OF THE HIGH-RISE DORMITORY (CORLEW HALL) IN 1967. Pictured from left to right, Dean Martha Hampton, Dean Chester Burns, Val Smith, Ray Roads, and Dean Robert MacLean celebrate the grand opening of a new women's dormitory. This building was later named Corlew Hall after Robert Corlew, who joined the history faculty in 1949, served as department chair and later became Dean of the College of Liberal Arts (1978–1984) and vice-president for academic affairs (1984–1990).

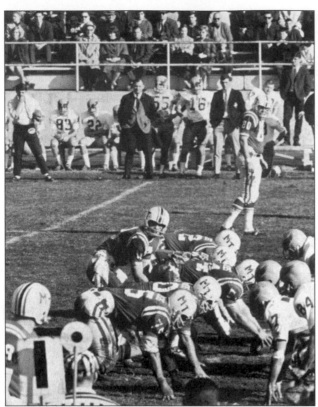

MTSU Confronting Rival Tennessee Tech. The OVC's "Number One Quarterback" of 1968, Billy Walker, calls plays against Tennessee Tech.

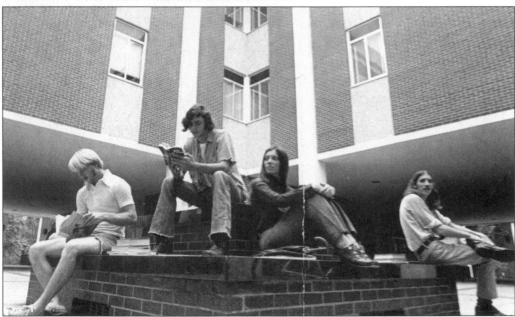

Relaxing in the Courtyard of Peck Hall. Completed in 1968, this classroom building was subsequently named in honor of Richard and Virginia Peck. Dr. Richard Peck served as chairman of the English Department from 1946 to 1973. The building, situated directly across from Kirksey Old Main, is now a campus landmark.

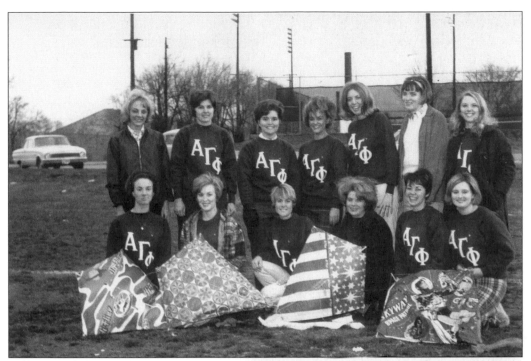

PLEDGES OF ALPHA GAMMA PI. The first sorority on campus was Alpha Gamma Pi, and MTSU's chapter formed in 1969.

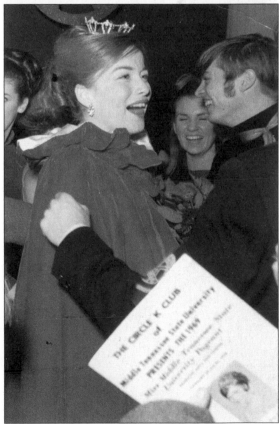

MISS MIDDLE TENNESSEE STATE UNIVERSITY, 1969. Connie O'Connell won the first Miss MTSU Pageant in 1969. The Circle K Club, a service organization for men, sponsored the pageant.

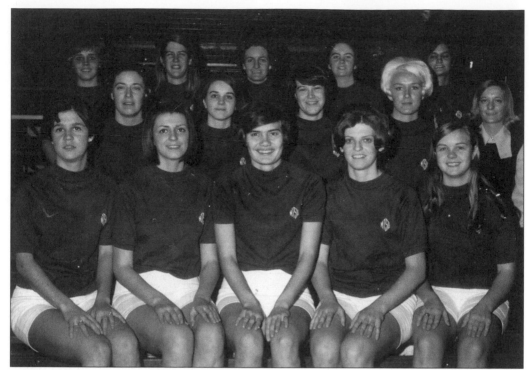

WOMEN'S INTRAMURAL BASKETBALL TEAM, 1969. Only after Congress passed the 1972 Title IX Educational Amendments to the 1964 Civil Rights Act did MTSU (like other universities) begin slowly to provide better funding and support for intercollegiate women's athletic programs.

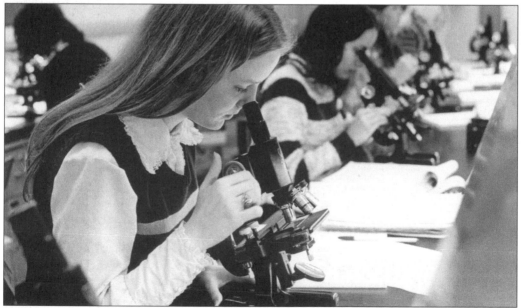

BIOLOGY CLASS, c. 1970. The Science Department had been divided a decade earlier into two new departments, the Department of Biology, under Dr. John Anon Patten, and the Department of Chemistry and Physics under Dr. James Eldred Wiser.

104

GRAPHIC ARTS STUDENTS. In the 1970s, MTSU continued to expand its academic offerings. The Art Department added a program in graphic design, while Mass Communications added Recording Industry Management.

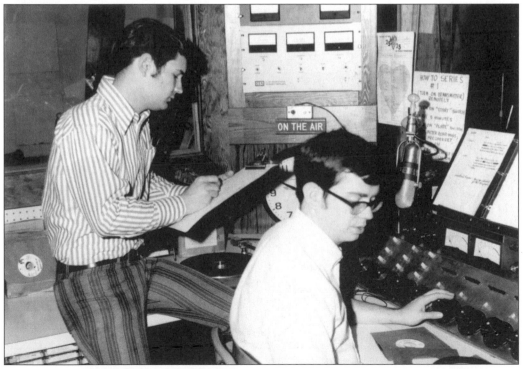

WMOT, THE CAMPUS RADIO STATION. WMOT began in 1970 with a hard rock format, later switched to classical music, and now heavily emphasizes jazz.

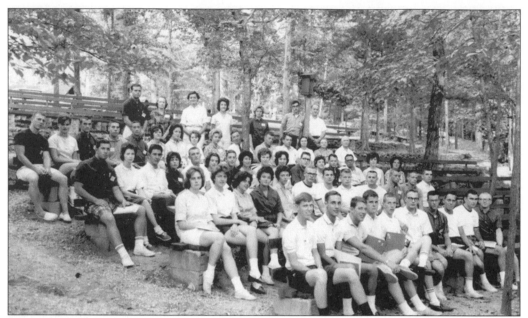

THE ASSOCIATED STUDENT BODY ANNUAL RETREAT. Student government played an important role on campus from its inception in 1939, and several Tennessee politicians began their careers in the ASB. Future congressman Bart Gordon, pictured below, ran successfully for ASB president in 1970–1971 under the slogan "Back Bart." In 1991, the Associated Student Body was renamed the Student Government Association.

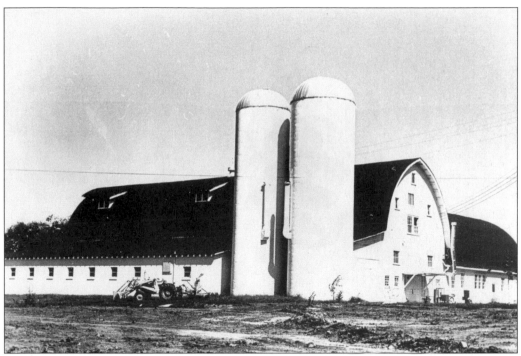

ART BARN. In the early 1970s, the Art Department moved into a barn vacated by the Agriculture Department. Art had attained department status 11 years earlier.

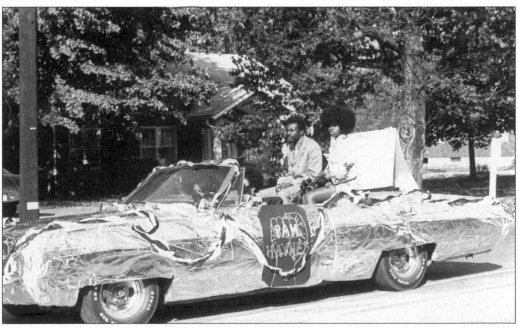

PAM HAYNES, 1972 HOMECOMING PARADE PARTICIPANT. The Black Student Association was formed in 1971 to represent the interests of African-American students on campus.

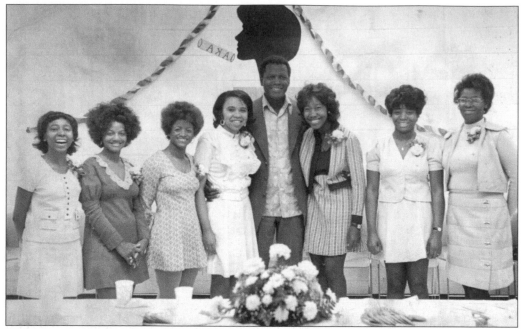

SIDNEY POITIER VISITS HIS GOD CHILD. The first African-American sorority on campus was Alpha Kappa Alpha. The local chapter formed in 1972. Sidney Poitier's god-daughter was a charter member, and he surprised her sorority sisters by attending the celebration.

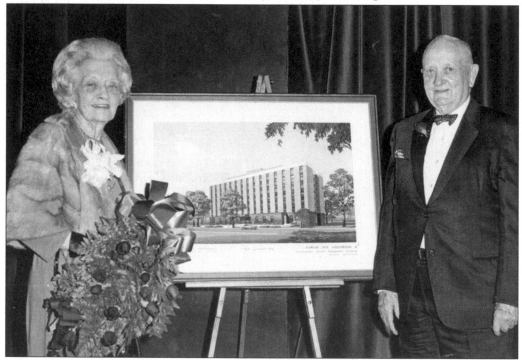

JIM CUMMINGS HALL. Mr. and Mrs. Jim Cummings attended the dedication of Cummings Hall in 1974. During "Mr. Jim's" 36-year career in the Tennessee General Assembly, he was well known for his support of higher education and MTSU.

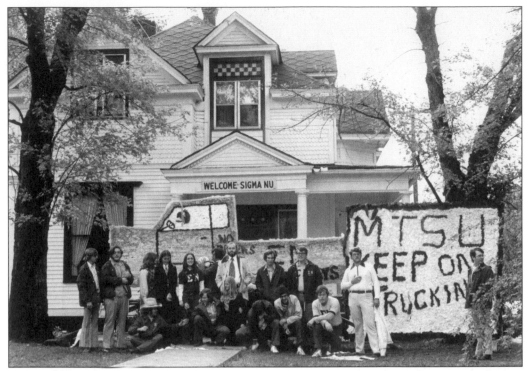

SIGMA NU HOUSE, 1970s. The Sigma Nu house is representative of the fraternities that made their homes in the neighborhoods surrounding campus in the 1970s. Fraternity row on campus was not completed until 1999, 30 years after *Sidelines* predicted, "Fraternity Row may be reality in near future."

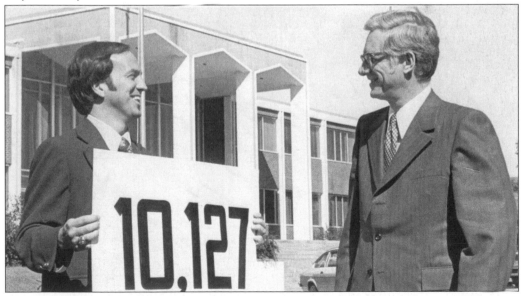

OVER 10,000 STUDENTS, 1974. President Melvin G. Scarlett celebrates reaching an enrollment of over 10,000 students. Scarlett worked to help MTSU fulfill its promise as a university by broadening the curriculum to include programs in aerospace and mass communications and by strengthening the business program.

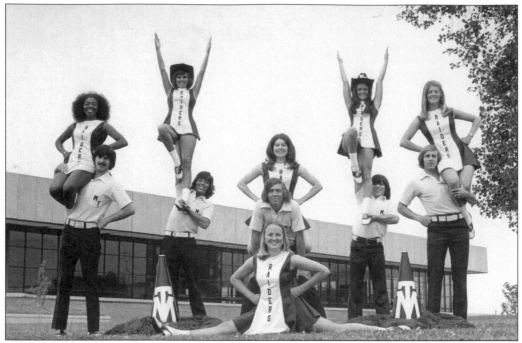

CHEERLEADING SQUAD, 1974–1975. Pictured from left to right are (front row) Karen Weeks; (middle row) Jim Coleman, Marty McClain, Jim Johnson, Betsy Child (behind Johnson), Eddie Gaines, and Tony Trumphour; (top row) Carolyn Spurgeon, Janie Jiles, Kathy Shouf, and Luanne Pitts.

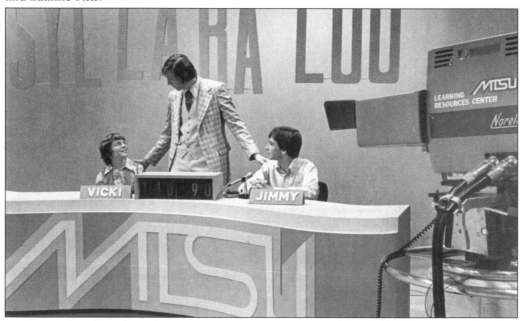

THE LEARNING RESOURCE CENTER (LRC). John Lannon hosts the game show, "Syllaraloo," featuring a contest between students at Eagleville High School and Riverdale High School. The LRC, completed in 1975, included television studios, computer labs, and a special room that simulated different environmental conditions.

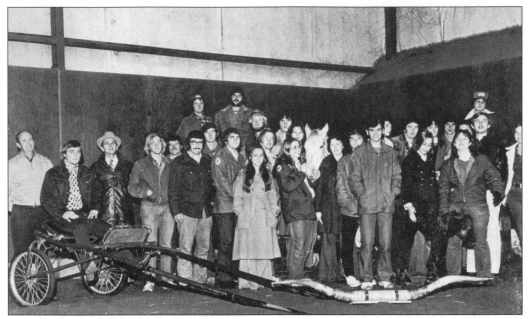

The Block and Bridle Club. This club was organized to foster academic achievement and camaraderie among animal husbandry students. Throughout the years activities included cattle shows, greased-pig chases, and horse shows. (Courtesy of Agriculture Department.)

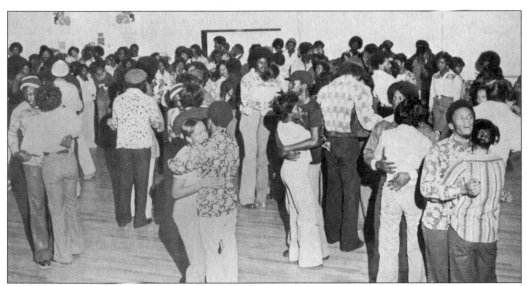

"Thursday Night 'Get-Down' Times at the JUB's Tennessee Room." The ballroom of the James Union building has hosted a wide variety of festivities over the years, including regular Thursday night dances in the 1970s. (*Midlander*, 1976.)

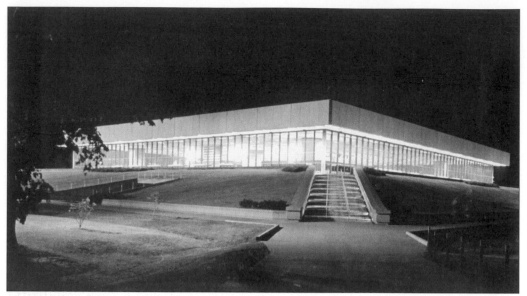

THE MURPHY CENTER. The Murphy Center was one of the first major building projects undertaken by Dr. Melvin Scarlett. Completed in 1972, the center seats over 11,000 and accommodates basketball games, graduation, and special events such as concerts. Elvis Presley played the Murphy Center five times during 1974 and 1975. The facility also houses many of the athletic program offices and provides some classroom space as well.

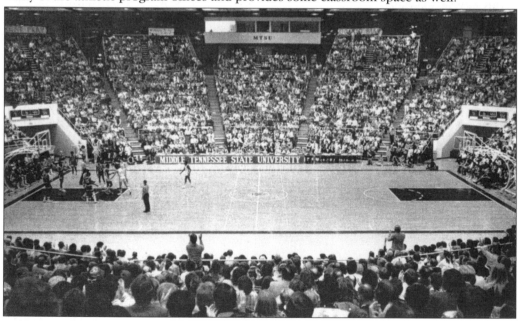

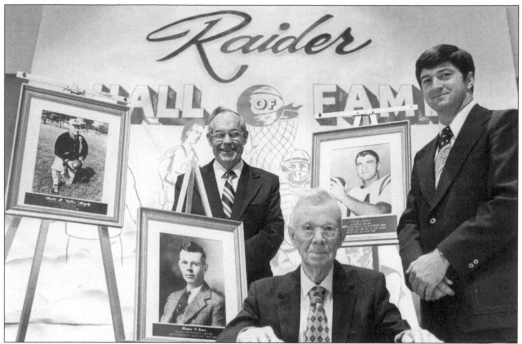

BLUE RAIDER HALL OF FAME, 1976. Joe Nunley (seated), Coach "Bubber" Murphy (left), and Teddy Morrie (right) were the first inductees into the Blue Raider Hall of Fame.

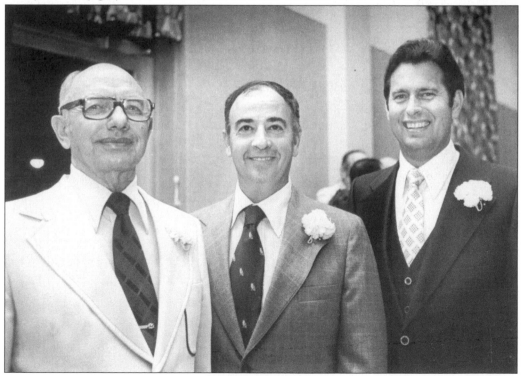

DISTINGUISHED ALUMNI, 1977. Pictured from left to right are recipients Leonard Mansfield, T.J Sharber, and John Ellington.

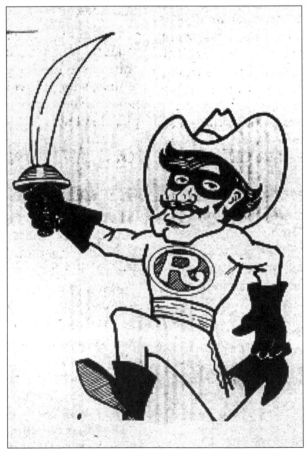

A New Logo, 1978. This MTSU logo replaced Gen. Nathan Bedford Forrest as the official symbol of the university. Student Sylvester Brooks began the movement to change the logo in 1968 when he wrote a *Sidelines* article stating that the Confederate flag, the song "Dixie," and Nathan Bedford Forrest were offensive to African-American students at MTSU. The ASB gridlocked on the issue after holding public meetings to get student responses. The controversy took ten years to fully resolve. By 1978, "Dixie" had fallen into disuse, the Confederate flag largely disappeared from athletic events, and the new logo appeared to replace the image of Nathan Bedford Forrest.

A Different Blue Raider. In order to make the Blue Raider appeal to more students, the mascot changed several times. In 1978, the character wore a black mask and a flowing cape.

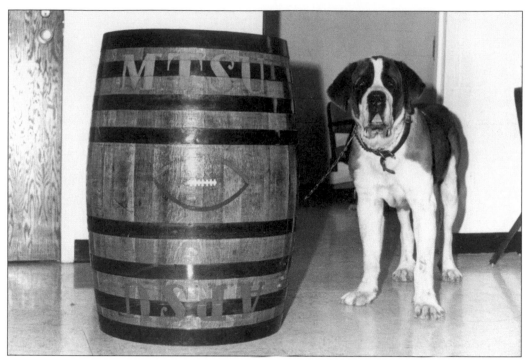

BEAUREGARD, THE ST. BERNARD. One of the fraternities donated a St. Bernard, named Beauregard, to the school and he accompanied the mascot during games in the late 1970s. In this picture, Beauregard guards the MTSU/Austin Peay State victory keg.

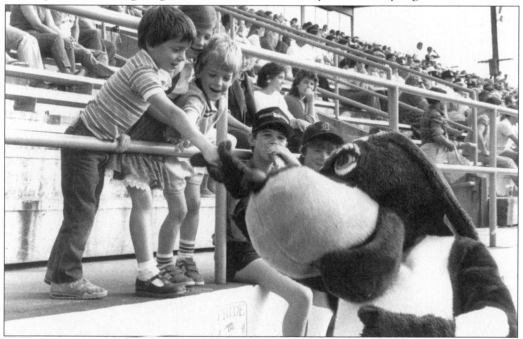

OLE BLUE ENTERTAINING FUTURE BLUE RAIDERS. Although Ole Blue, pictured here, was never an official mascot of the Blue Raiders, he was popular with MTSU fans during the 1980s. A Blue Raider fan had the dog costume and debuted it at a basketball game.

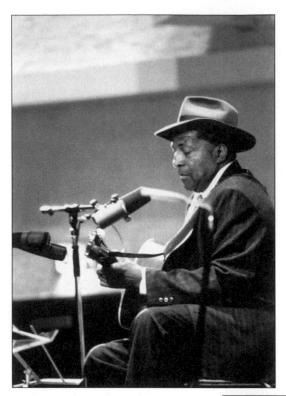

THE CENTERS OF EXCELLENCE. One of the many accomplished musicians brought to campus by the Center for Popular Music is pictured here. The Tennessee General Assembly created a competition to establish research centers in Tennessee's public colleges and universities in 1984. The Center for Historic Preservation was the first MTSU program to receive Center of Excellence designation. The Center for Popular Music was established as a Center of Excellence in 1985 to promote scholarship about American popular music. (Courtesy of Center for Popular Music.)

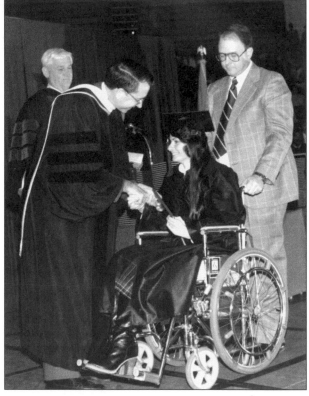

SUPPORTING THE DISABLED. MTSU has gone beyond federal requirements to help disabled students since the early 1980s. In 1985, MTSU hired John Harris to direct the Office of Disabled Student Services. One hundred fifteen students with diagnosed disabilities were enrolled at MTSU in 1985. By 1999 that number had risen to 756.

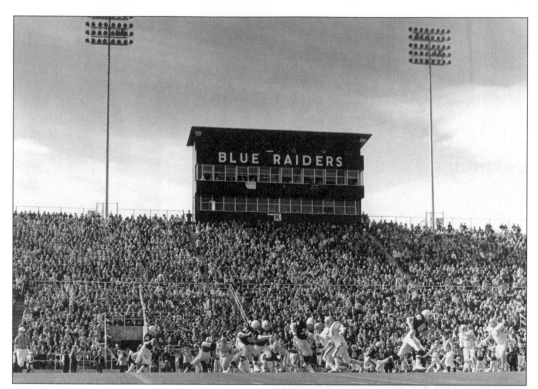

A PACKED HOUSE FOR THE BLUE RAIDERS.
Boots Donnelly began a successful football
coaching career at MTSU in 1978. In 1985,
Donnelly led the Blue Raiders to their first
OVC championship in 20 years. Donnelly
retired in 1998.

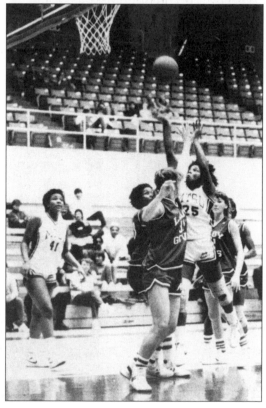

LADY RAIDERS BASKETBALL TEAM, 1986.
The Lady Raiders were very successful
in their division, eventually winning
OVC championships.

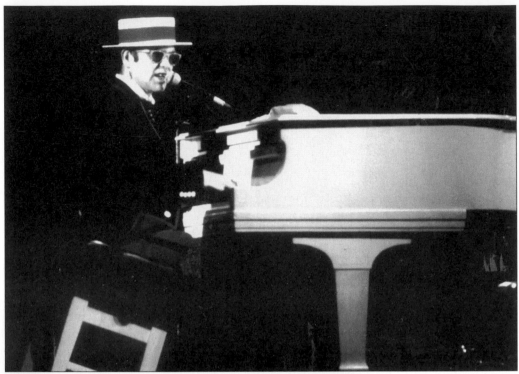

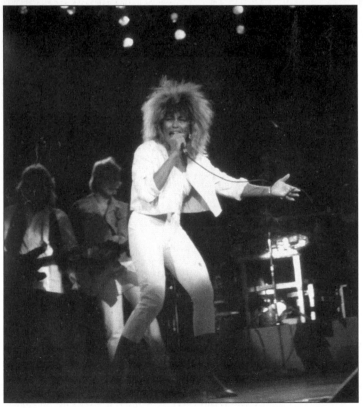

ELTON JOHN ROCKS THE MURPHY CENTER. (Courtesy of MTSU Photographic Services.)

TINA TURNER KEPT THE MURPHY CENTER ROLLIN' IN 1987. The Elvis concerts in the mid-1970s were just the beginning of the Murphy Center's career as a major rock-and-roll concert venue. In addition to Elton John and Tina Turner, artists like the Rolling Stones; Bruce Springsteen; the Who; John Cougar Mellencamp; Crosby, Stills and Nash; the Eagles; Chicago; Kenny Rogers; Journey; and Rod Stewart all played at the Murphy Center. (Courtesy of MTSU Photographic Services.)

ROTC Continues. By 1986 MTSU's Army ROTC program had produced five generals. The program has also provided additional opportunities for women. Currently, it is one of the top-rated ROTC programs in the nation.

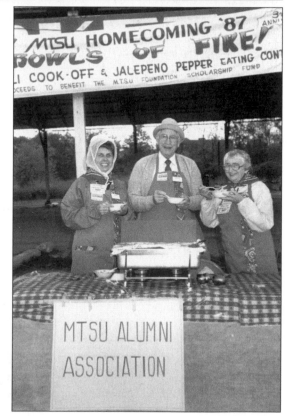

Homecoming, 1987. Alumni Charlene Key ('64), Charlie Grigsby ('36), and Zadie Key ('41) (left to right) enjoy a bowl of chili at an Alumni Association event.

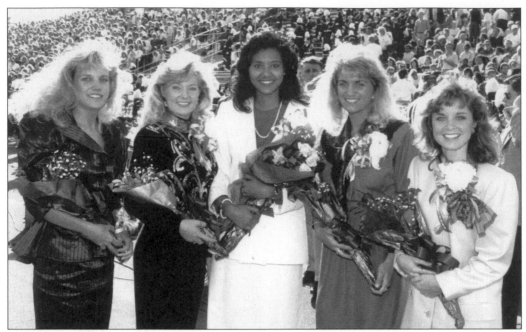

HOMECOMING COURT, 1988. Homecoming queen Mona Evan poses with her court. From left to right are Jenni Stakup, Jo Ellen Drennon, Evan, Jenny Contrell, and Priscilla Corn. MTSU's first African-American homecoming queen was Barbara Gibson, elected in 1978.

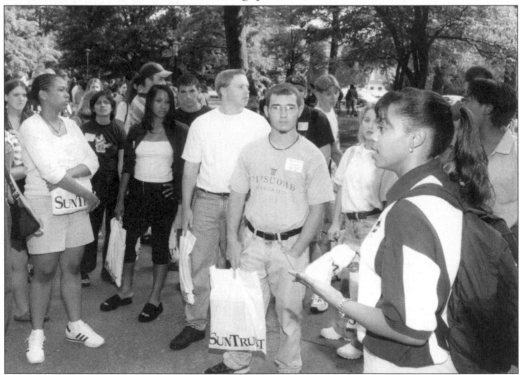

ORIENTATION TOUR. The SGA gives tours to students during orientation. (Courtesy of MTSU Photographic Services.)

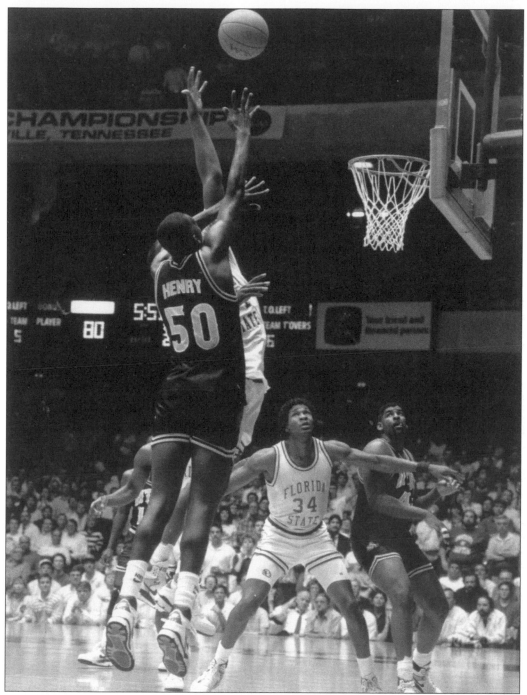

BLUE RAIDER BASKETBALL FAME, 1989. As Ohio Valley Conference champions in 1989, MTSU upset Florida State in the first round of the NCAA Southeast Regional Tournament. MTSU had made it to the NCAA tournament for the first time in school history in 1982. The Blue Raiders then played the heavily favored Kentucky Wildcats, who were making their 27th appearance in the tournament. But the Blue Raiders defeated the Wildcats 50-44, in one of the most memorable games in school history.

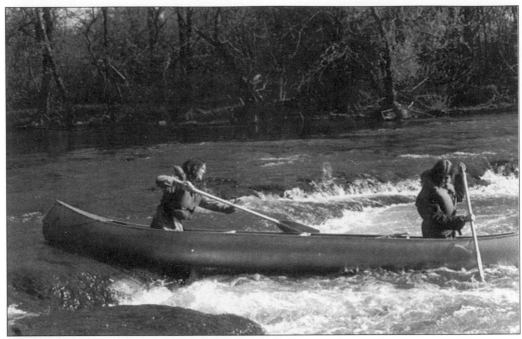

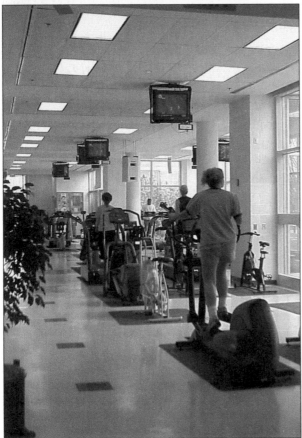

CAMPUS RECREATION CENTER CANOE TRIP. The Rec Center, as it is known to students, opened in 1996. Through the SGA, students voted to assess an additional fee for all students to help pay for the center. The recreation staff helps run the center, offers aerobics classes, aquatics, weight training, and recreation for the disabled. They also sponsor adventure trips. (Courtesy of Health, Physical Education, Recreation, and Safety Department.)

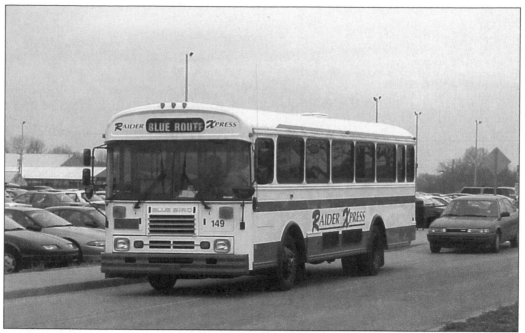

RAIDER EXPRESS. The Raider Express bus service was started in 1994 to help alleviate parking problems and to help students find a quick way across campus.

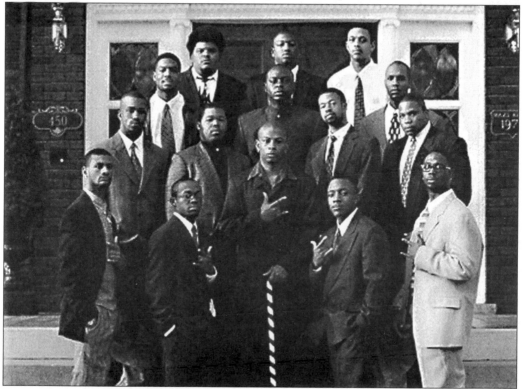

PHI BETA SIGMA. Greek life continues to provide many students with opportunities for involvement on campus.

STUDENTS IN THE COURTYARD OF THE BUSINESS AND AEROSPACE BUILDING (BAS). The BAS opened in 1998 showcasing new technology, such as air traffic control and flight training simulators, a real-time weather station, and 41 master classrooms with internet links and computer projection systems.

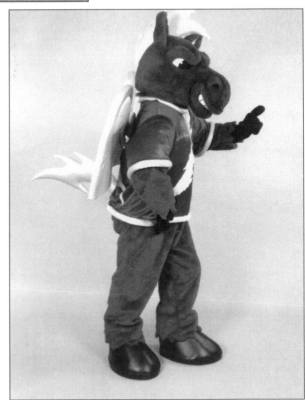

LIGHTNING, THE CURRENT BLUE RAIDER MASCOT. "Lightning" was introduced in 1998 with a new official athletic logo. (Courtesy of MTSU Photographic Services.)

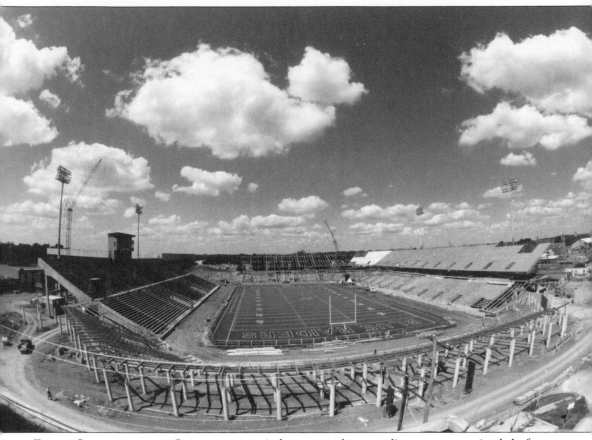

FLOYD STADIUM UNDER CONSTRUCTION. A large, modern stadium was required before MTSU's football program could achieve NCAA Division I status. The stadium, which opened in 1998, seats 30,100 and has 16 luxury suites and 12 boxes. (Courtesy of MTSU Photographic Services.)

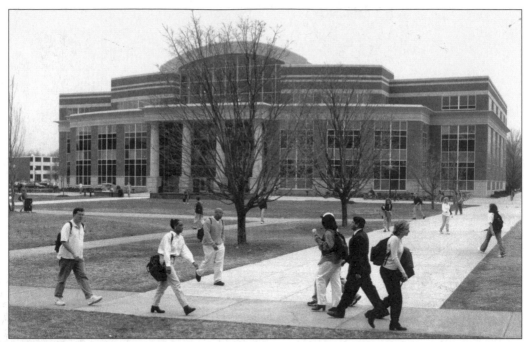

NEW LIBRARY. This 250,000-square-foot library replaced the Todd Library in 1999 in order to better meet the needs of the growing university. The library has study space for 2,500 and a capacity for 800,000 volumes. (Courtesy of MTSU Photographic Services.)

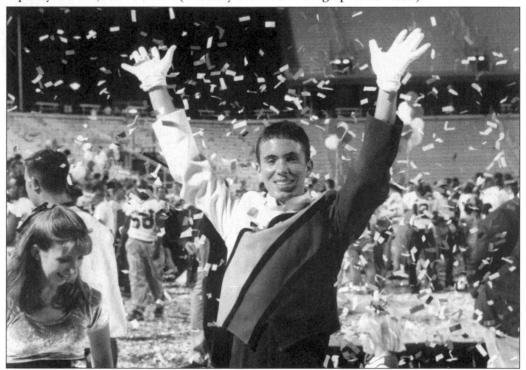

1999 DIVISION IA CELEBRATION. Fans gather in Floyd Stadium to celebrate the Blue Raiders entry into Division IA football. (Courtesy of MTSU Photographic Services.)

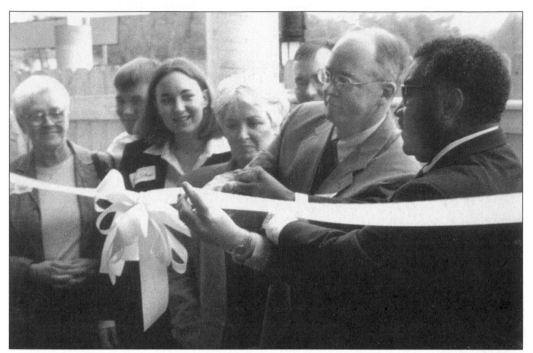

GREEK ROW, 2000. Dr. Cliff Gillespie cuts the ribbon on the Kappa Sigma house that was named in his honor. Through a partnership with the eight participating fraternities, MTSU's Greek Row was completed after a 30-year wait. (Courtesy of News and Public Affairs.)

MTSU PRESIDENT JAMES WALKER (1990-2000). Dr. James Walker, the seventh president of MTSU, accomplished many goals in his ten years at MTSU, including establishing an Honors College, creating and following an Academic and Facilities Master Plan, increasing admissions standards, and providing more academic scholarships.

MTSU—The College of Individual Opportunity. MTSU has grown from a small institution for teachers to a university with one of the largest enrollments in the state. It still continues, however, to offer "individual opportunity" for its students, a mission first proclaimed in the promotional literature of the 1950s. (Courtesy of MTSU Photographic Services.)